SCOTLAND
THE · LIGHT · AND · THE · LAND

PHOTOGRAPHS · BY · COLIN · BAXTER

Salem House

SALEM NEW HAMPSHIRE

First published in the United States
by Salem House, 1985.
A member of the Merrimack Publishers' Circle,
47 Pelham Road, Salem NH 03079

Library of Congress Catalog Card Number
84-052247
ISBN 0 88162 086 6

© Copyright Colin Baxter 1985
Designed by Charles Miller Graphics
Words by R. A. James

Printed in Italy by
New Interlitho S.p.A., Milan

It is summer and a sweltering Scotland reaps a bumper harvest. Wave upon wave of ripe tourists sweeps in by road, rail and air to spill over ancient monuments and hills and mills and shops, inexorably drawn by images of loch and glen and ancient battleground. Though undoubtedly well armed with cameras, they will buy the cards and calendars and books proclaiming Scotland's Splendour, Scotland's Glory, Traditional Scotland or simply Scotland in Colour to reinforce their love affair with Scottishness.

This book is not about Scottishness but it is about Scotland: the country behind the myth, legend, history and romance, the inspiration for artist, patriot, Scot past, present and future. There is a timelessness about these photographs, which draw their strength from the elemental ingredients of sea and sky and land and light.

When Colin Baxter came to Scotland a few years ago, he recognized a photographer's dream when he saw one: an almost infinite source of pictures. These photographs have been taken over the past five years and represent a progress report so far. Although he has covered phenomenal distances, he knows there is so much still to be discovered and recorded.

Now photography has become the medium of the masses. The law of averages, combined with modern

technology, makes it inevitable that even the most cack-handed amateur photographer will achieve at least one masterpiece and the debate intensifies as to whether or not photography is really art. How can it be if anyone can do it? But what distinguishes the artist from other men is his ability to see and express, in whatever medium, aspects of human emotion or experience that would otherwise be overlooked: and to succeed in doing so over and over again.

Colin Baxter is modest about his achievements. He is even embarrassed by the ease with which he came by certain pictures–a question of being in the right place at the right time, with a camera–but if there is luck involved, he creates most of it. He is perpetually on the move, on the look-out for pictures and never without a camera. Journeys of exploration are planned with maps; locations noted for a revisit under specific conditions. But he is forever alert and responsive to those often momentary fusions of land and light that most of us have seen but all too rarely recognized and caught on films.

No book of Scottish landscape photographs can be definitive but in 'Scotland, the Light and the Land' Colin Baxter offers us a taste of the real thing and whets our appetite for more, much more to come.

Angus Ogilvy August, 1984

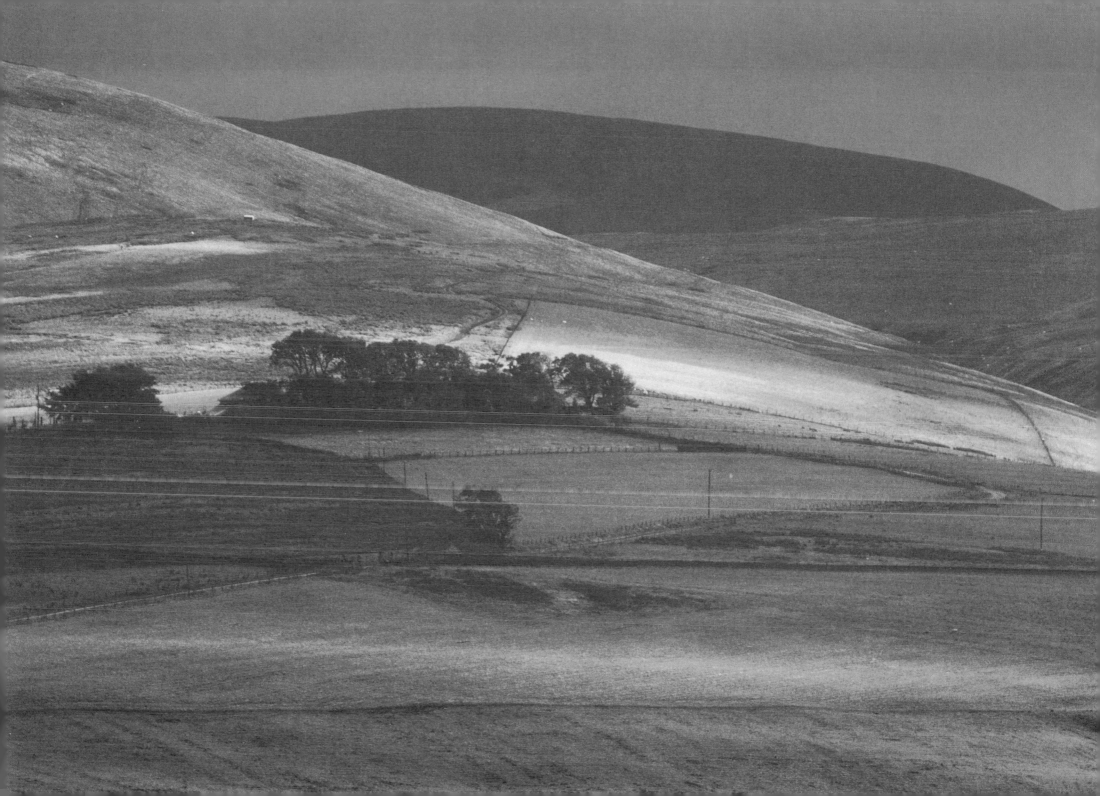

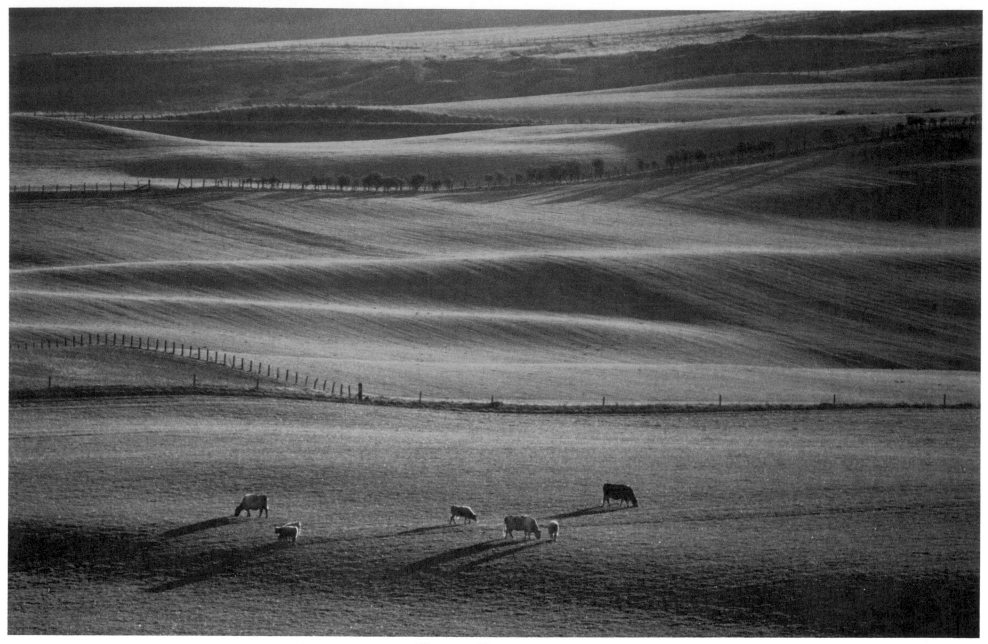

THE · BORDERS

6

iron
biting
brittle
whiting
dry
icing

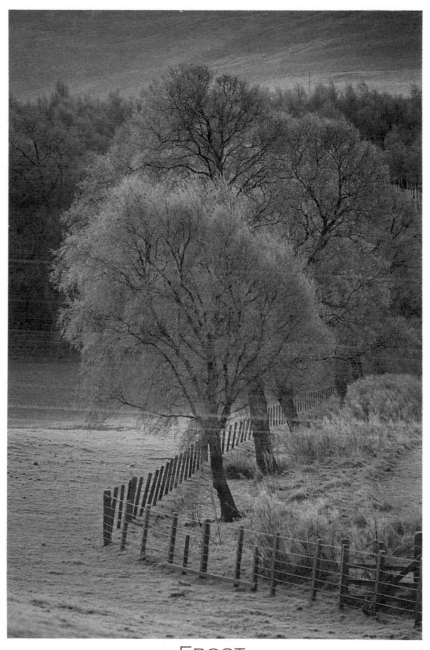

FROST

trailing
westerly
the sun's
gold
an interlock
of land
and water

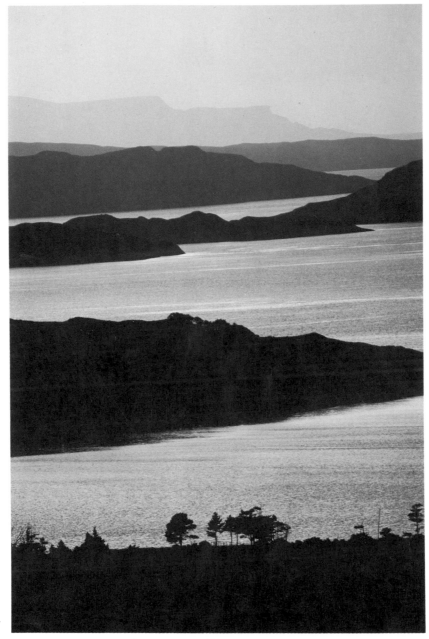

LOCH · TORRIDON

8

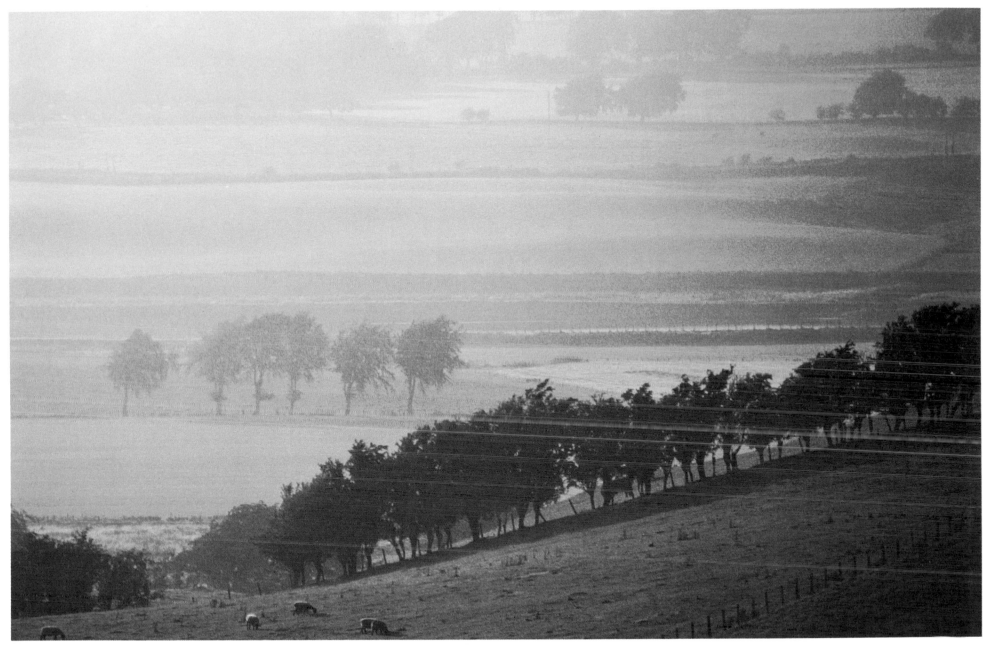

UPPER · CLYDE · VALLEY

9

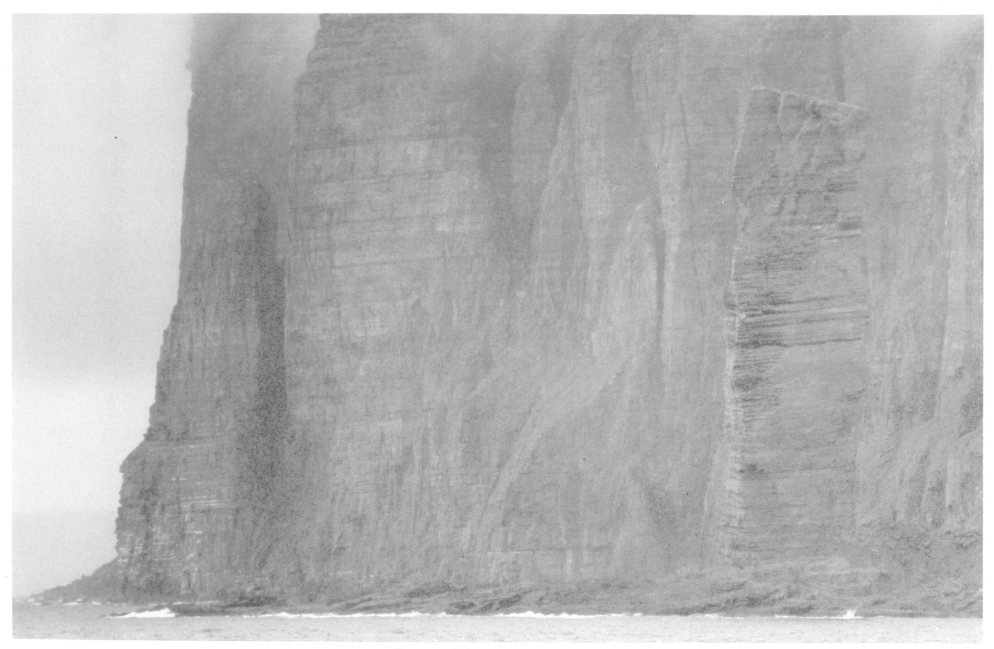

OLD · MAN · OF · HOY

10

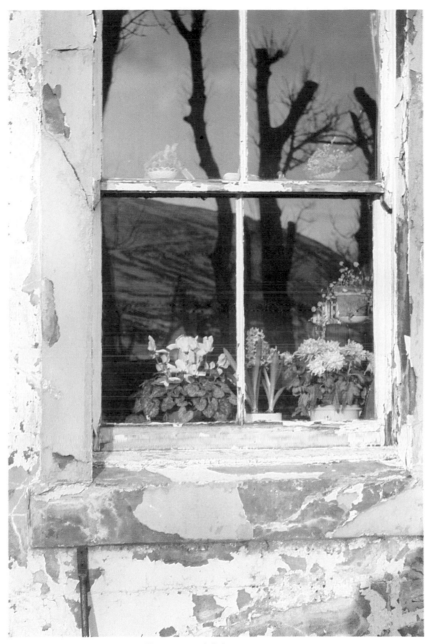

OLD · WINDOW

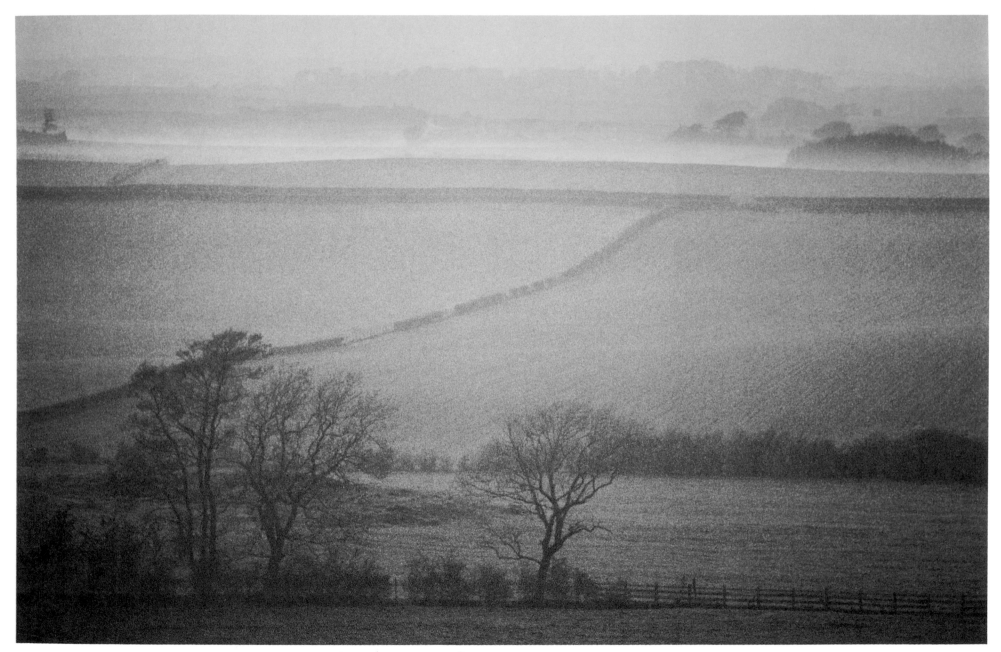

AYRSHIRE

12

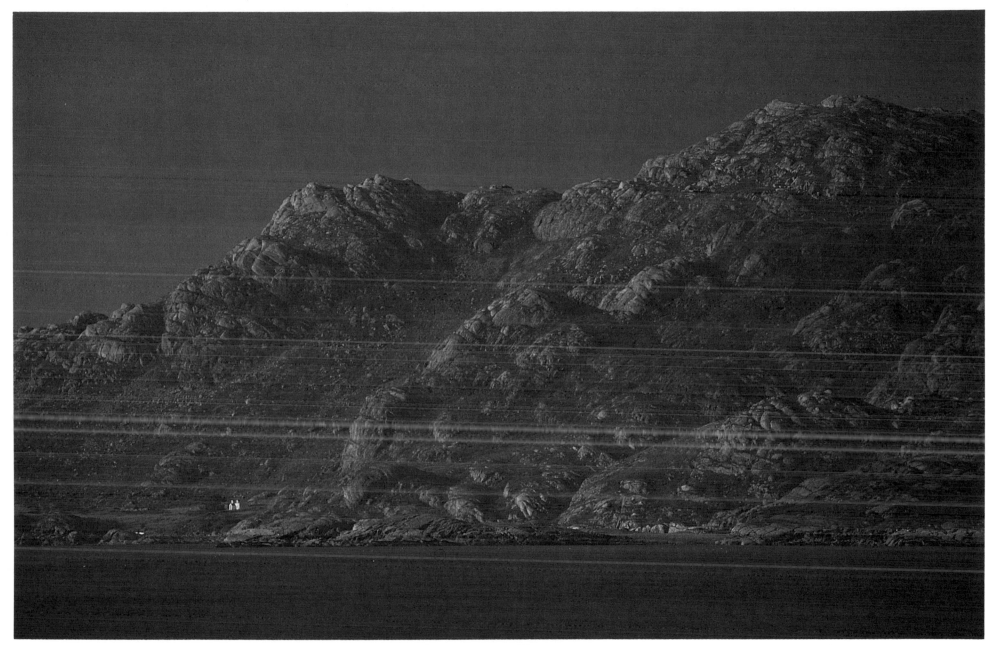

ALLIGIN · SHUAS

13

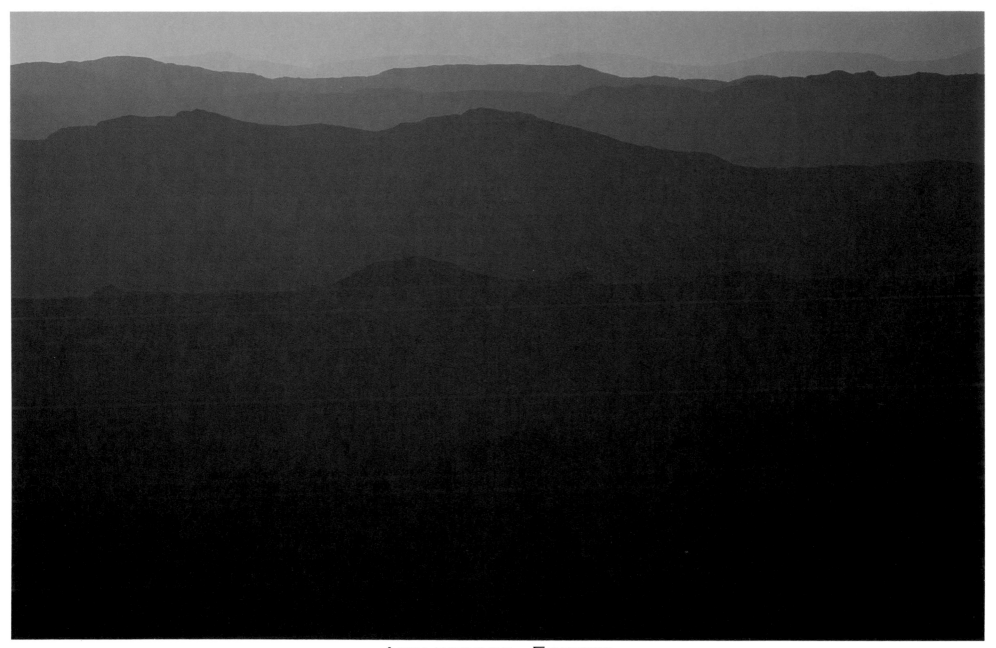

APPLECROSS · FOREST.

14

sunset
breaking
into mountains
wave
on wave

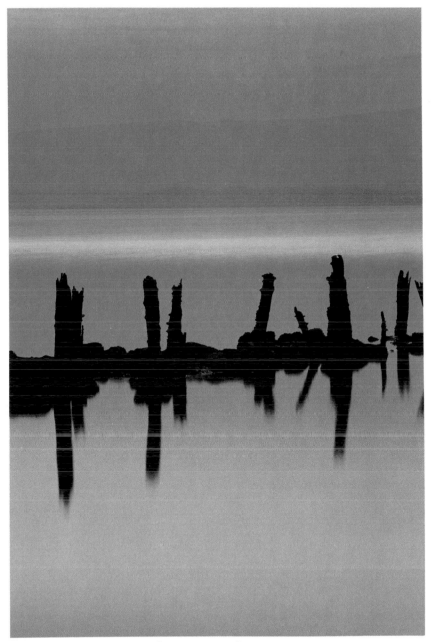

LOCH · AWE

15

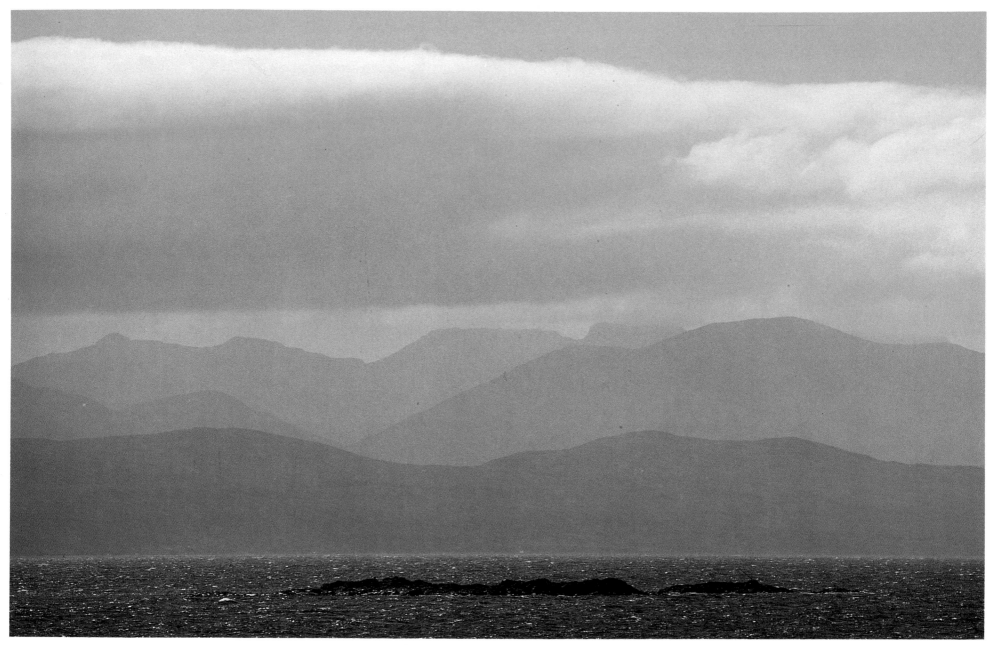

ISLE · OF · RAASAY

16

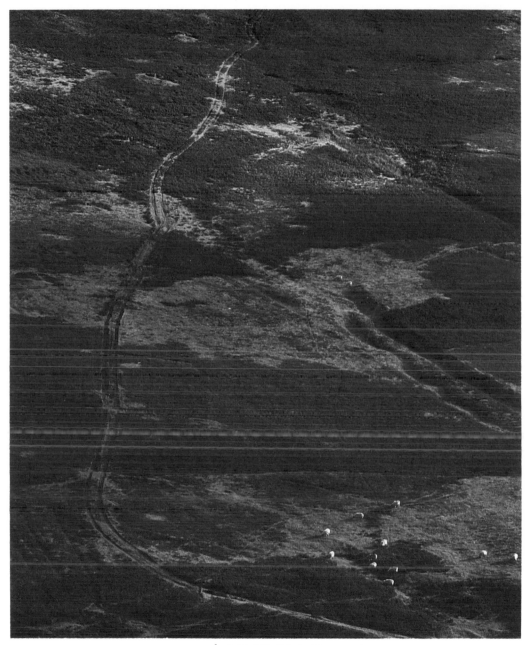

Leadhills

17

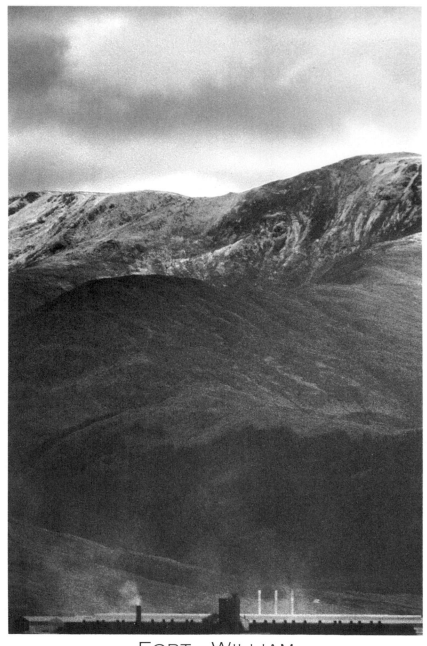

FORT · WILLIAM

CUNNINGHAME

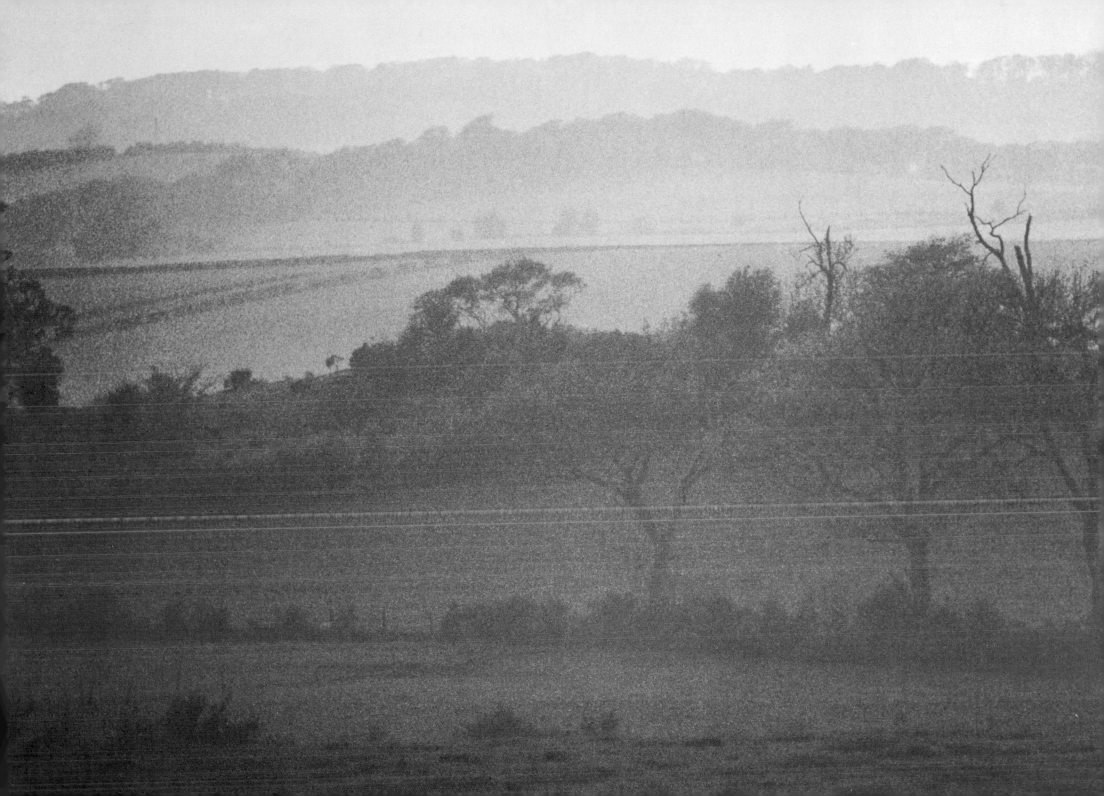

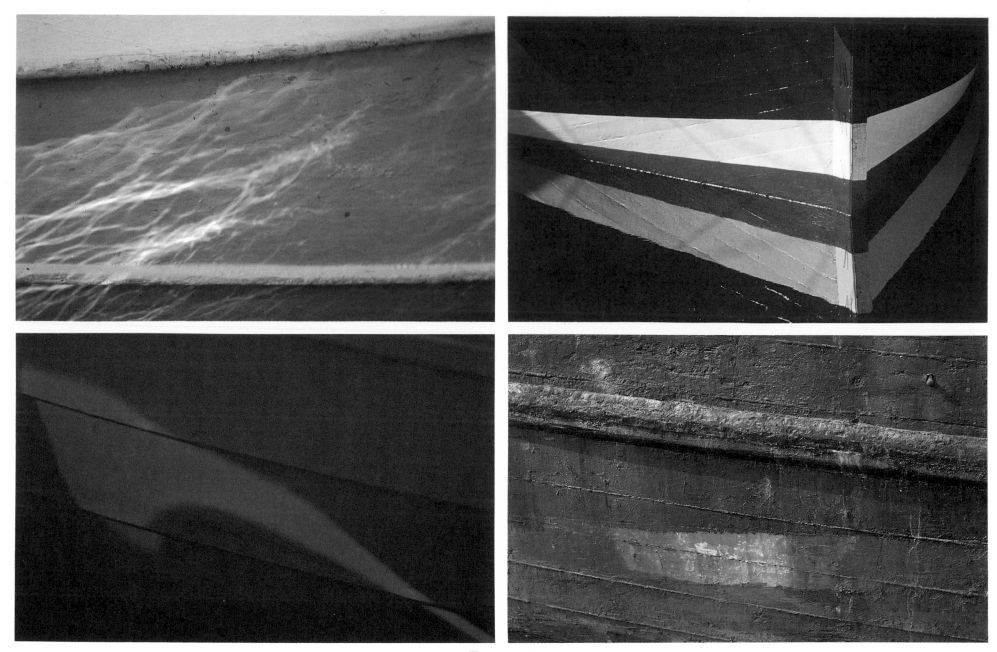

BOATS

20

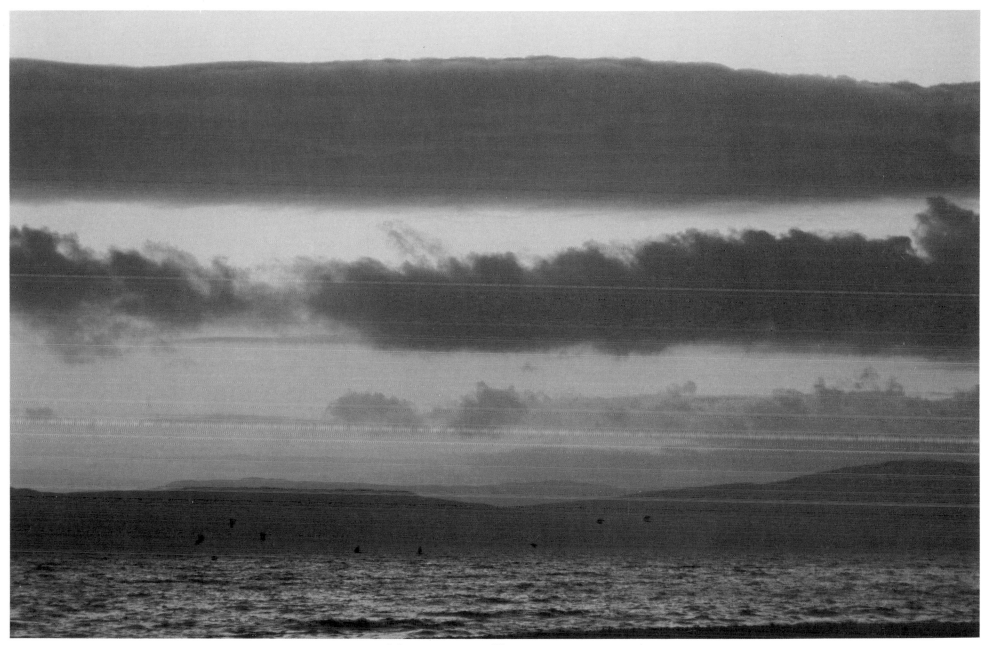

KINTYRE · PENINSULA

21

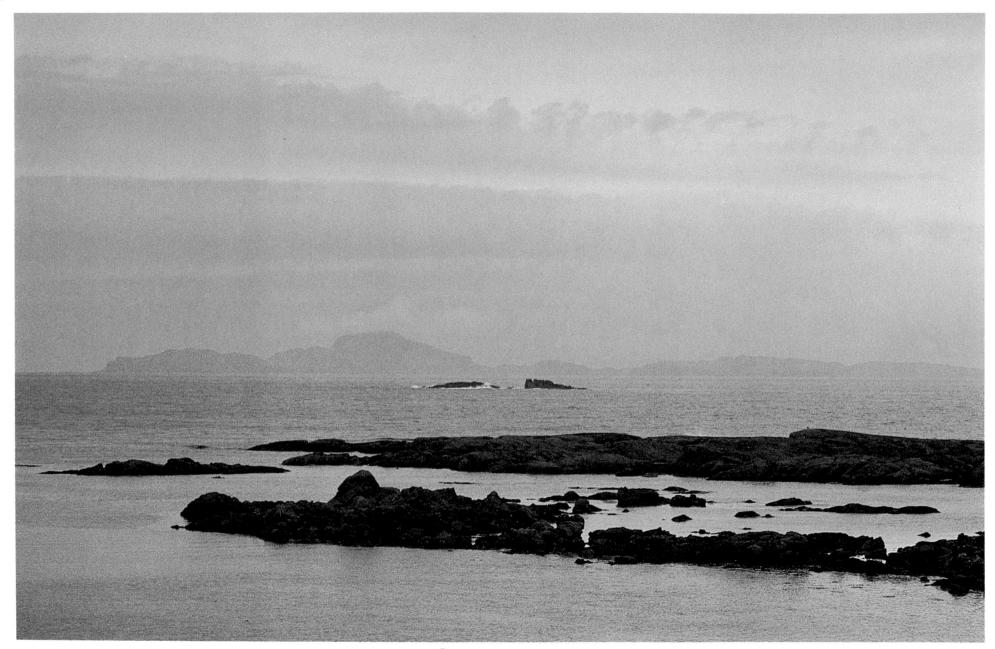

SANNA · BAY

22

shading
to brown
the ebb
and flow
of autumn
undulation

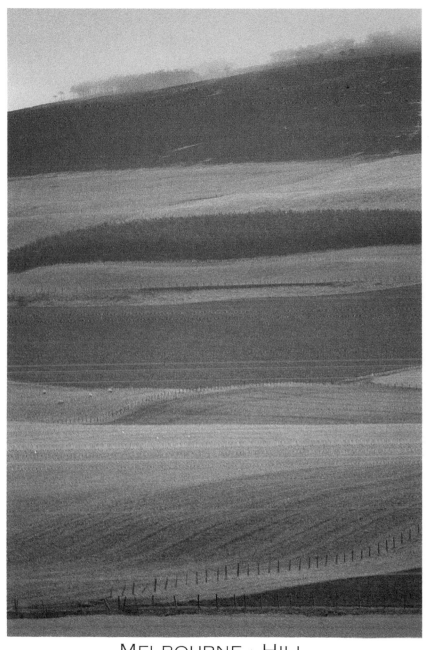

MELBOURNE · HILL

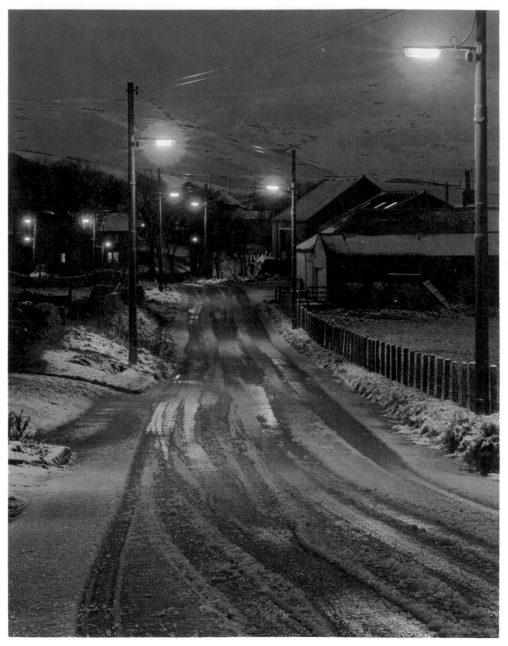

CRAWFORDJOHN

24

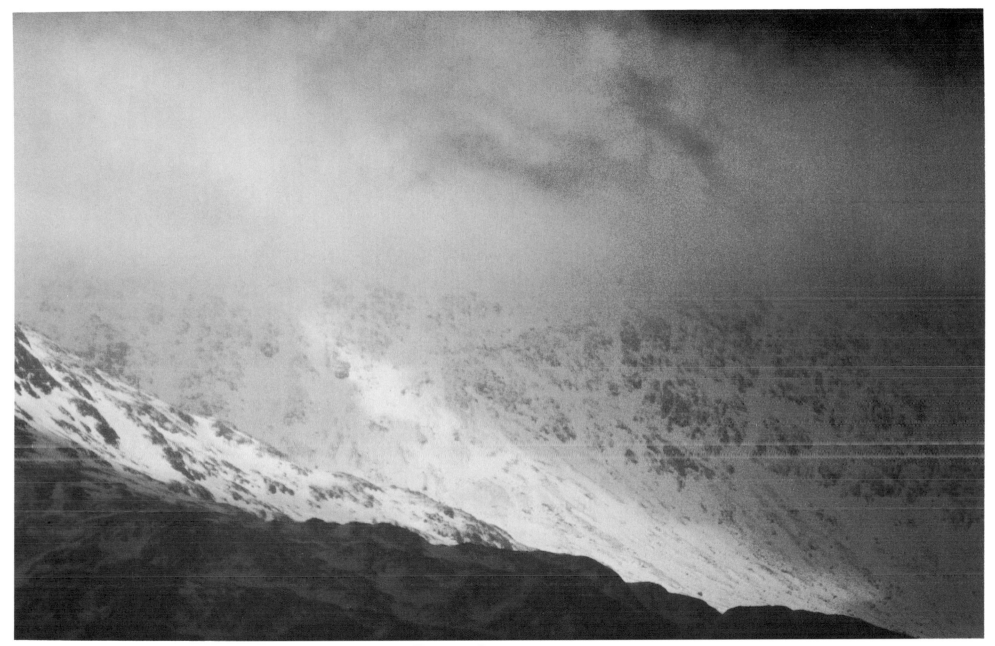

BEN · CRUACHAN

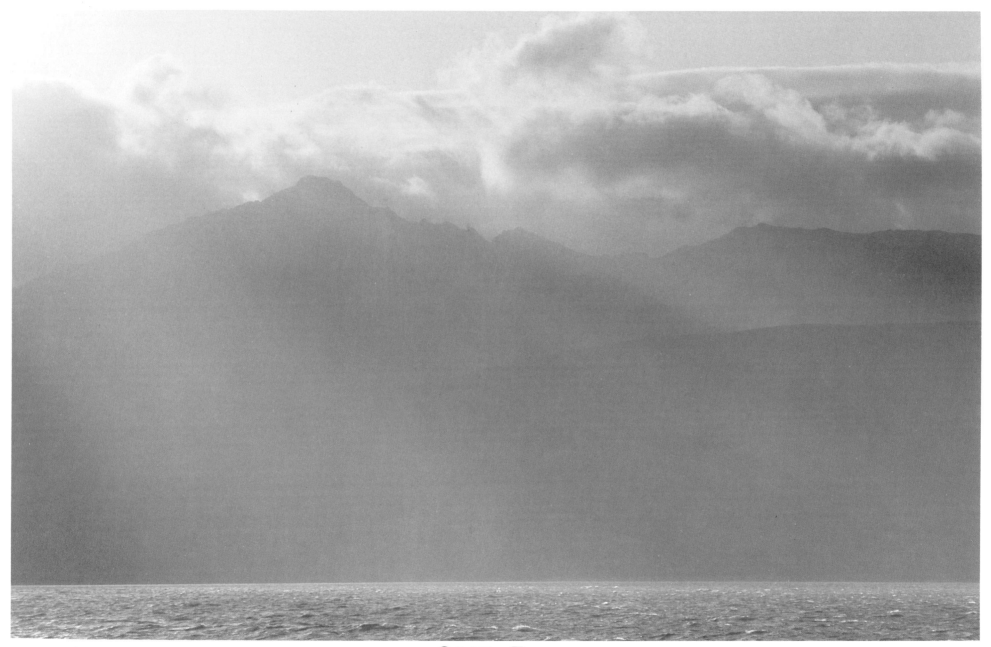

GOAT · FELL

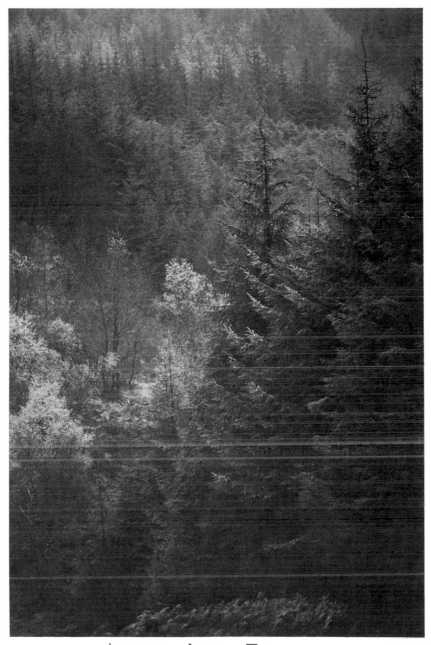

LOCH · ARD · FOREST

27

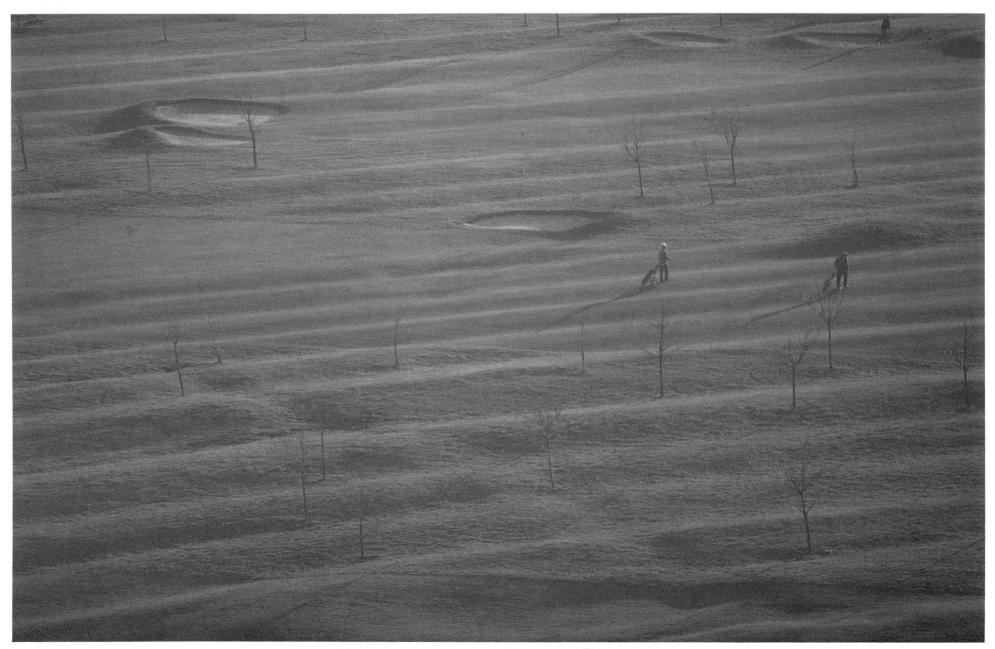

PRESTONFIELD · GOLF · COURSE

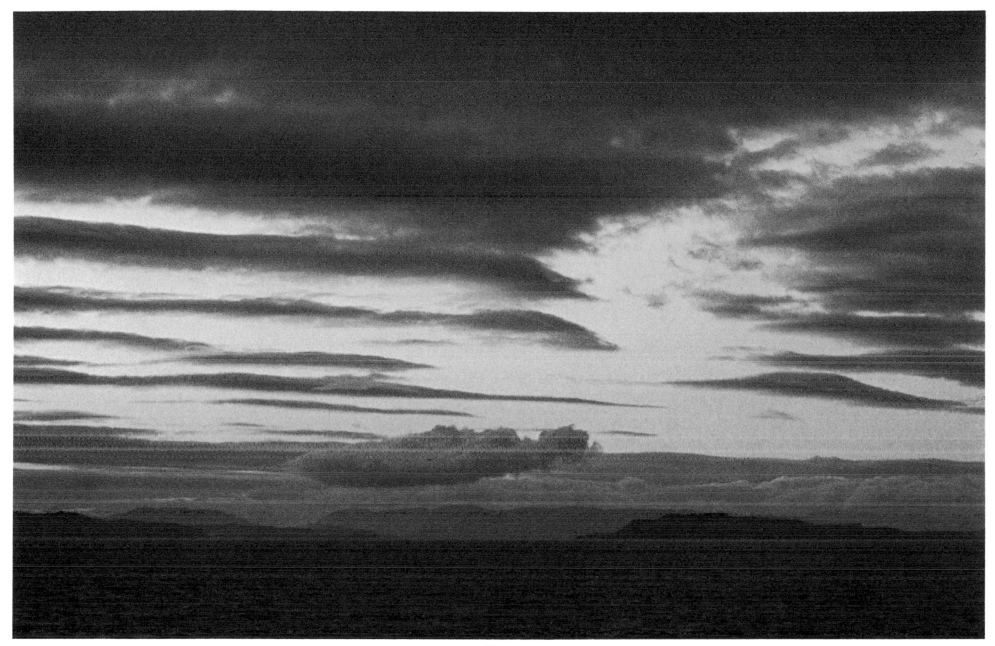

FIRTH · OF · CLYDE

29

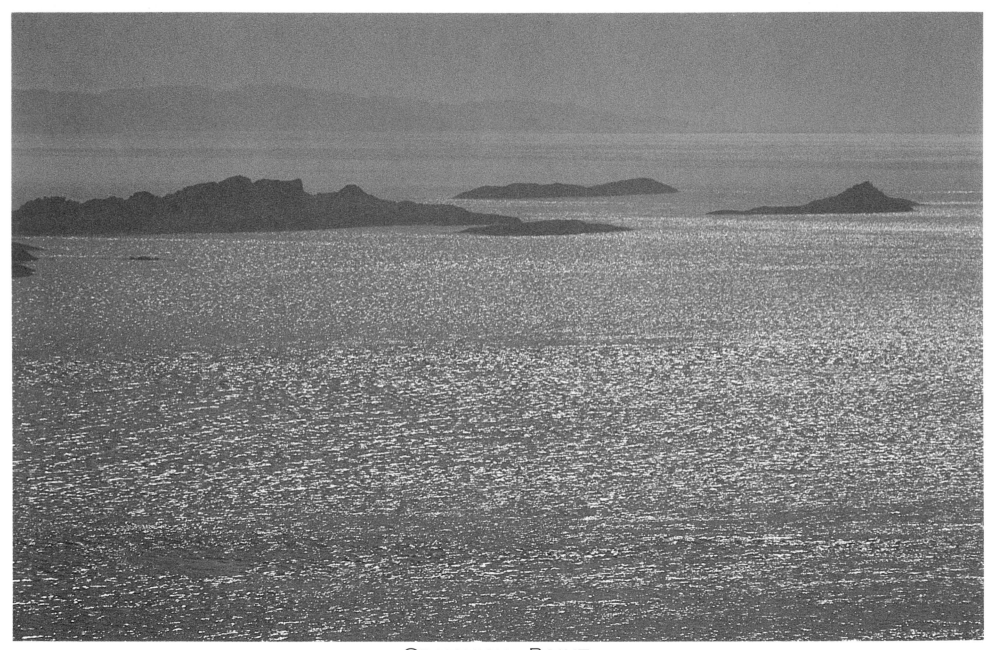

CRAIGNISH · POINT

shoaling
motionless
rock dorsals
chase
the sea

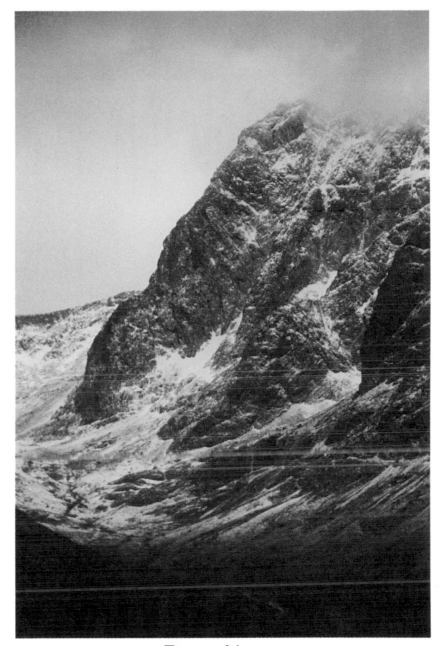

BEN · NEVIS

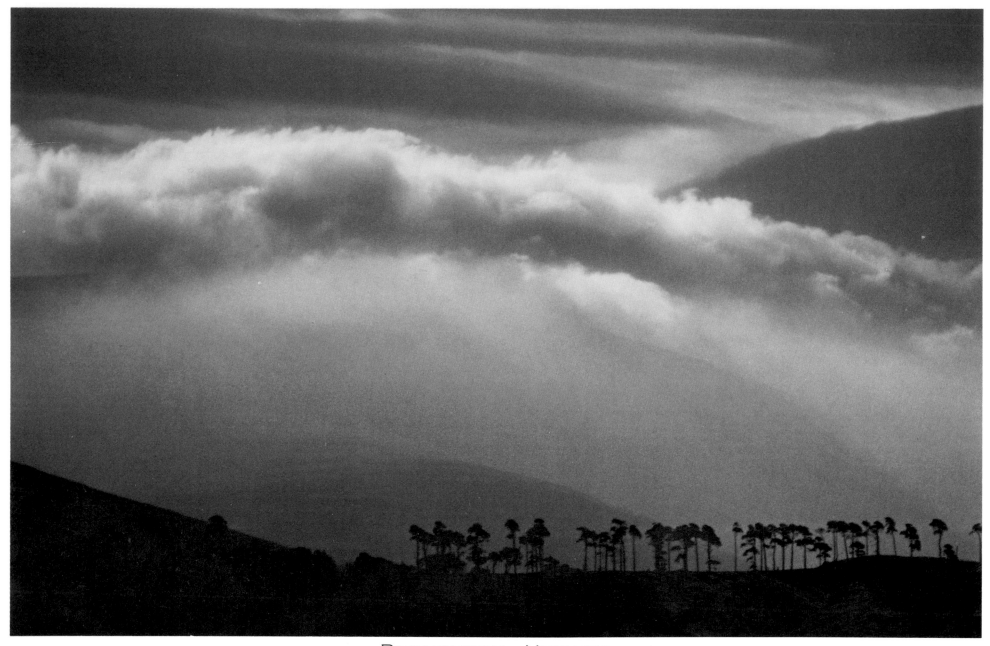

BROUGHTON · HEIGHTS

tree
figures
cloud
mountains
far
imaginings

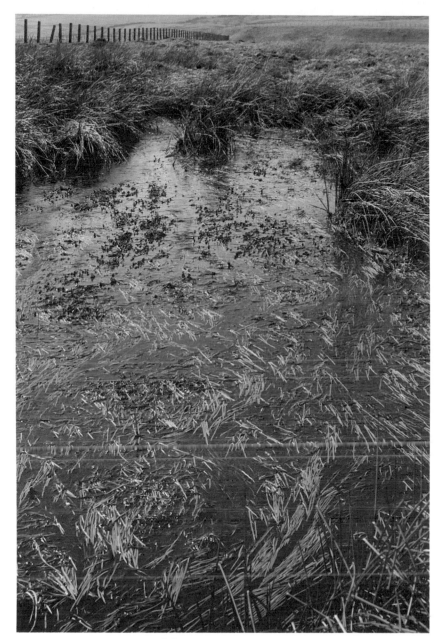

MARSHLAND

33

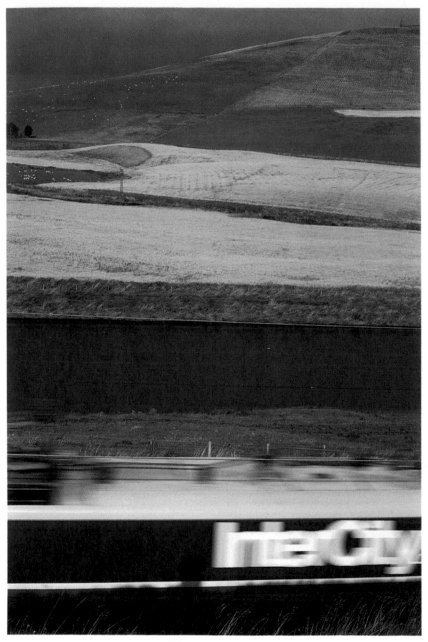

EXPRESS

34

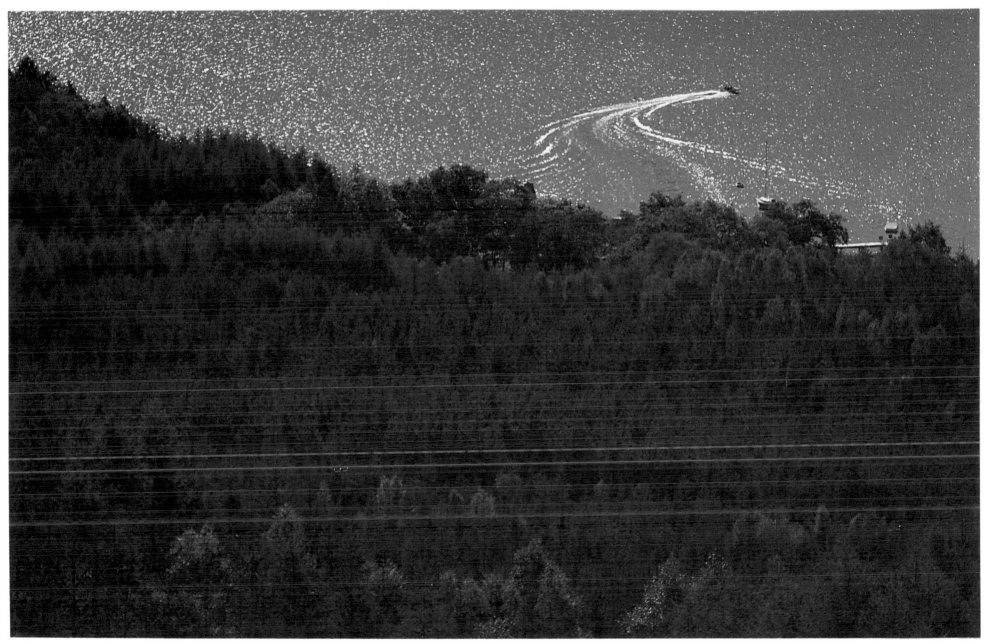

LOCH · LOMOND

35

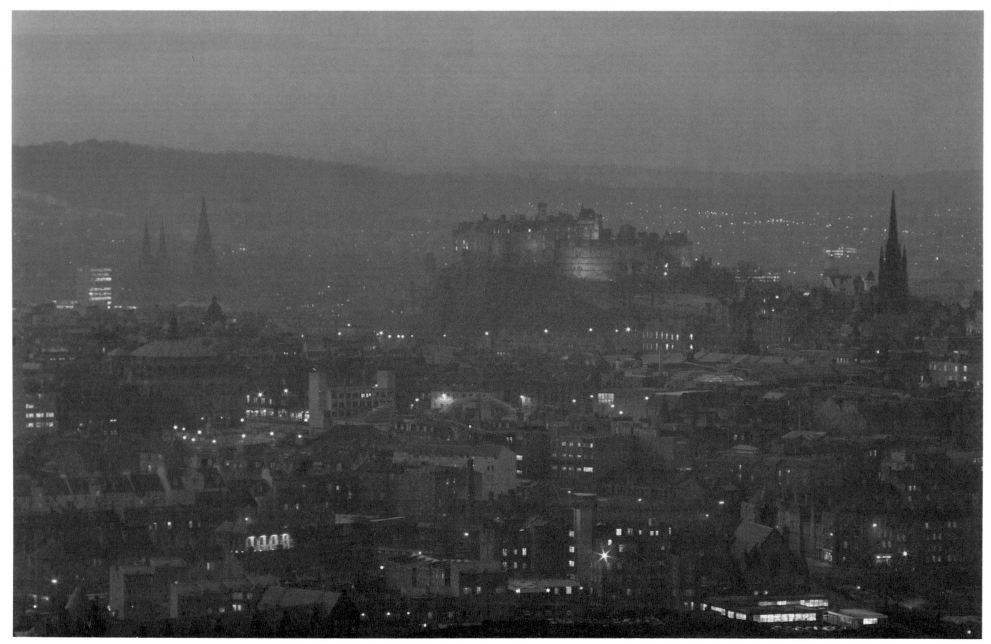

DUSK · OVER · EDINBURGH

36

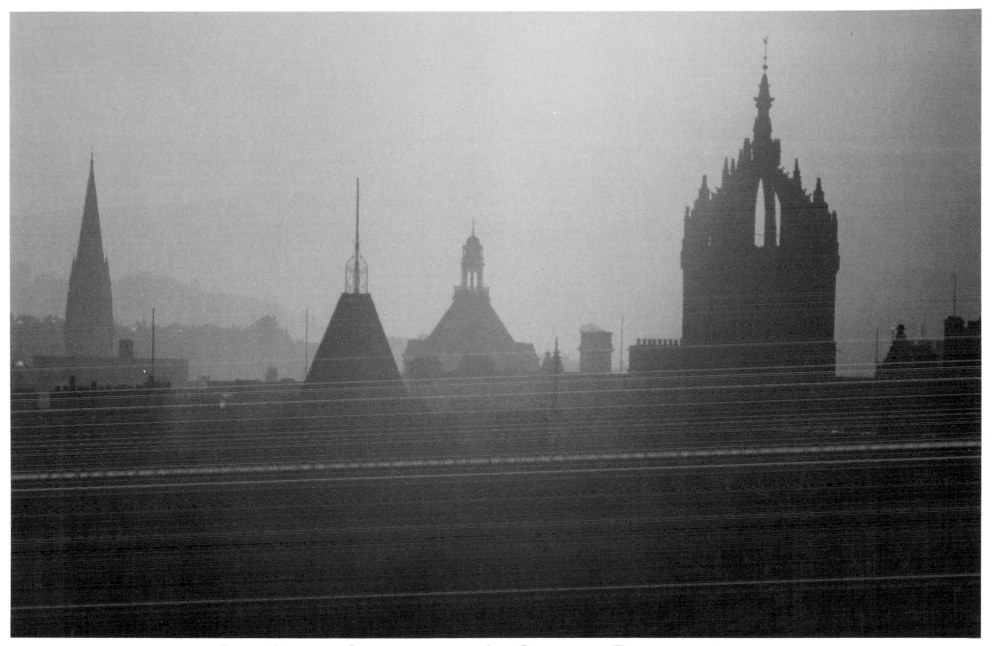

ST. · GILES · CATHEDRAL · & · SPIRES, · EDINBURGH

winter
pitted
the granite
blade

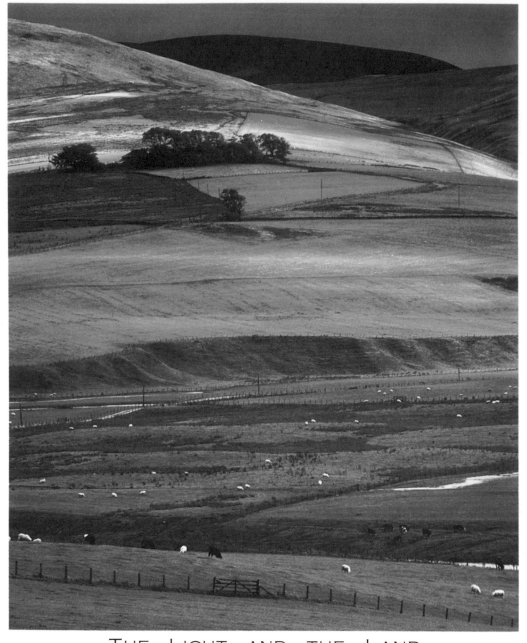

THE · LIGHT · AND · THE · LAND

BLACK · MOUNT

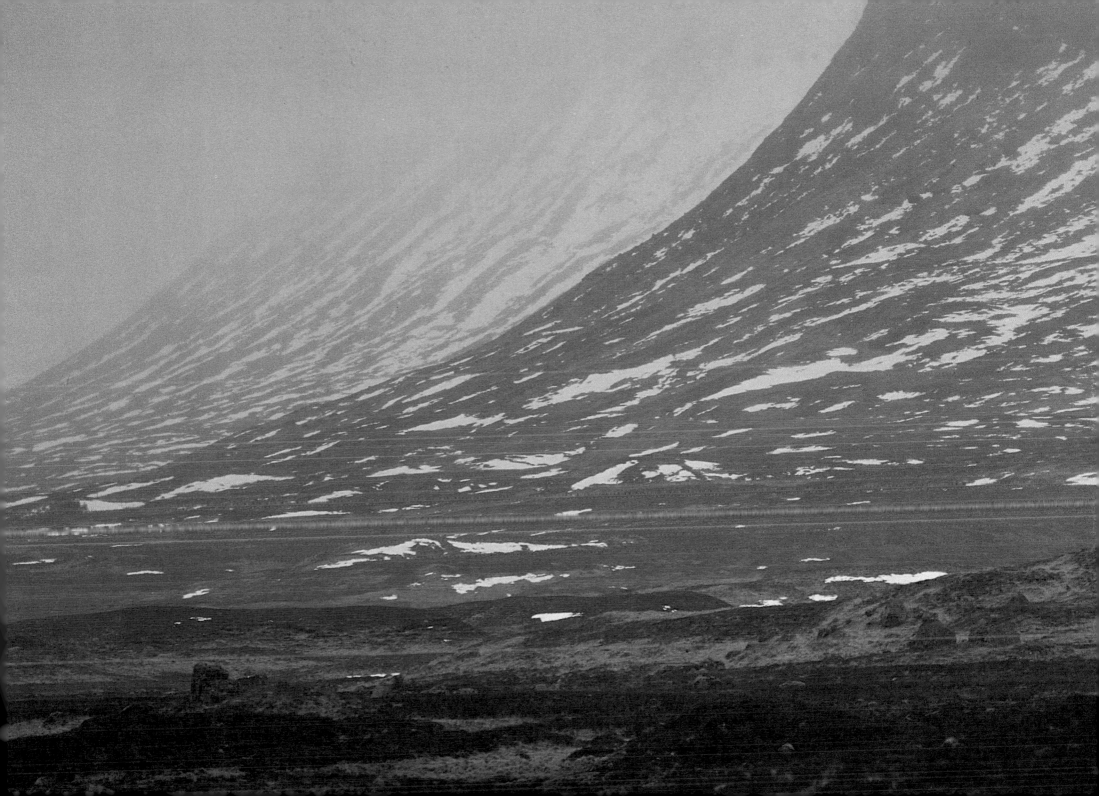

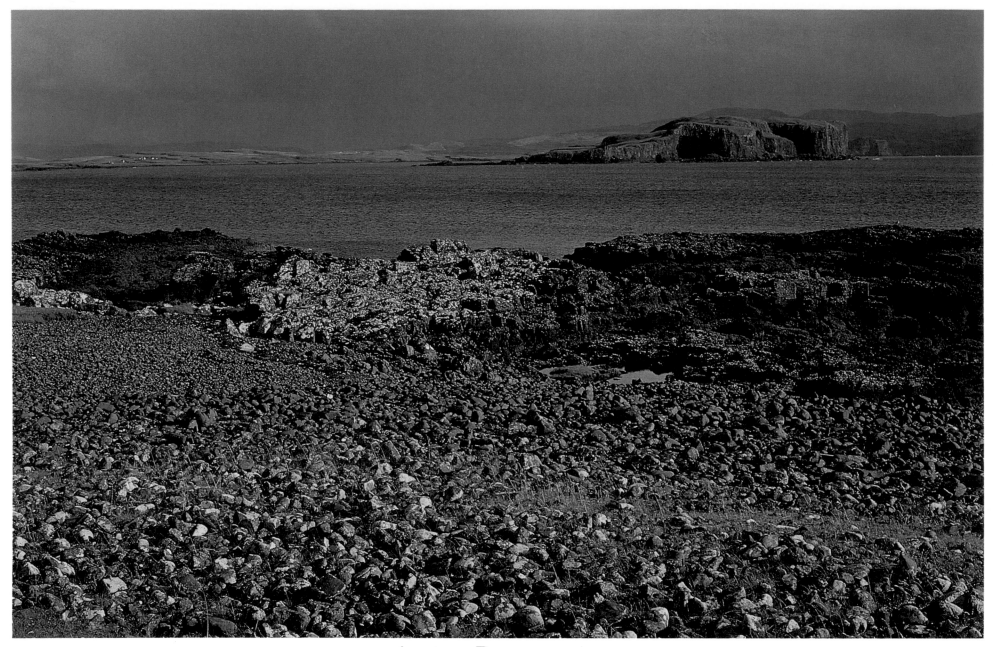

LOCH · BRACADALE

40

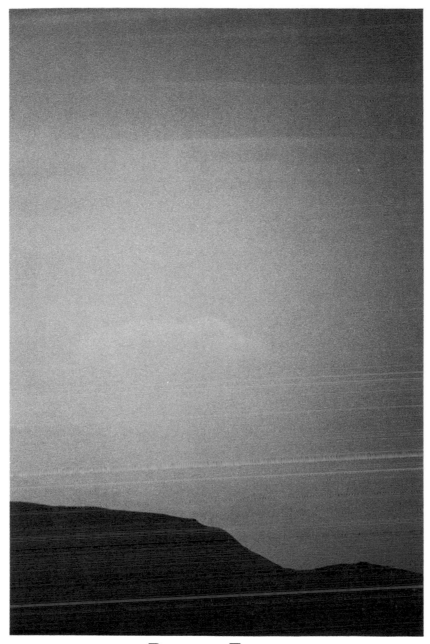

BEINN · EACH

41

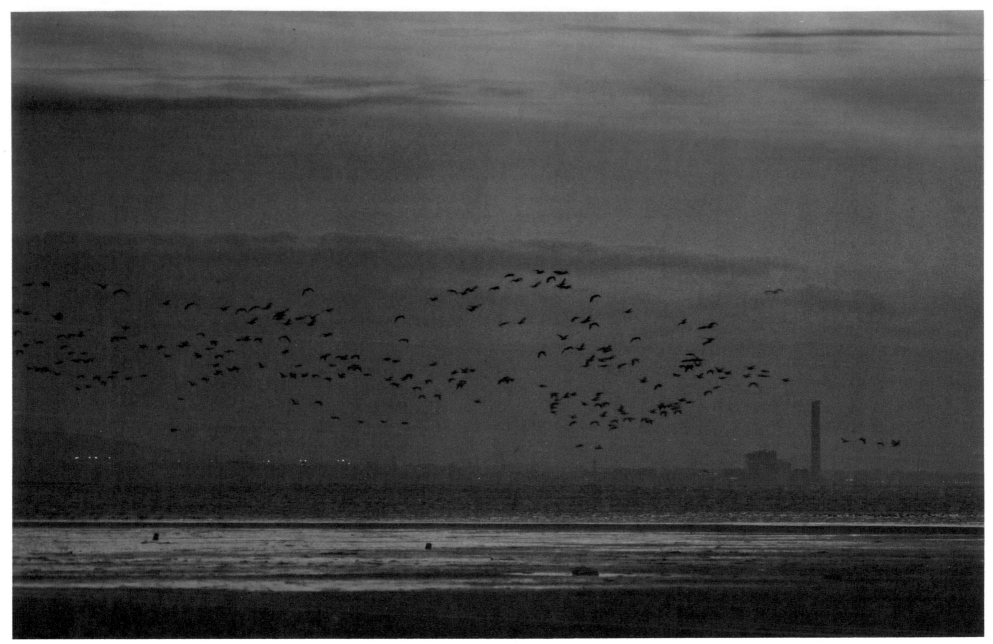

COCKENZIE · POWER · STATION

42

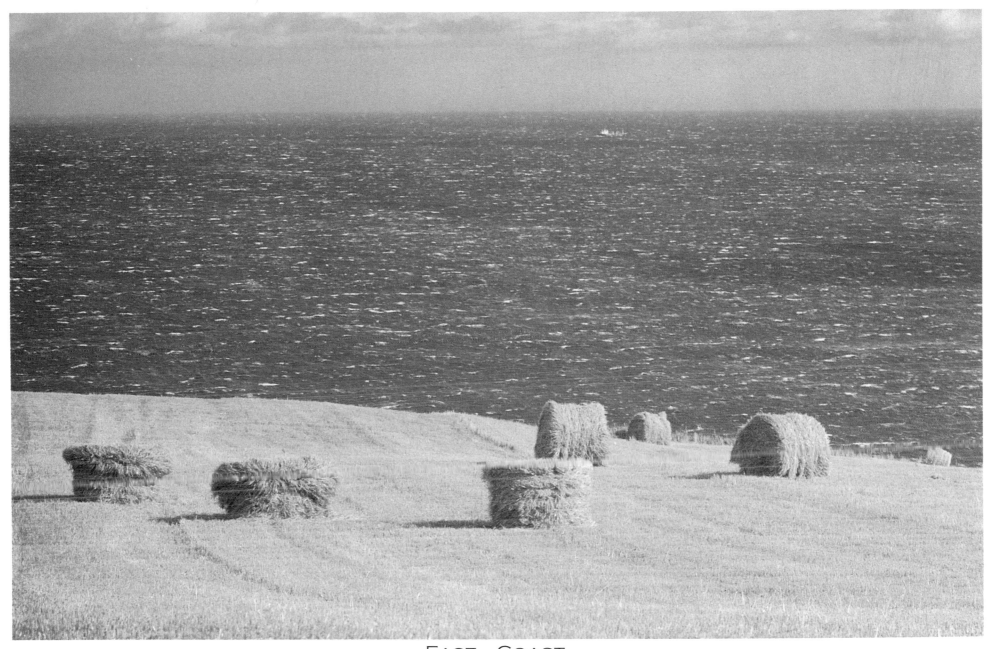

EAST · COAST

43

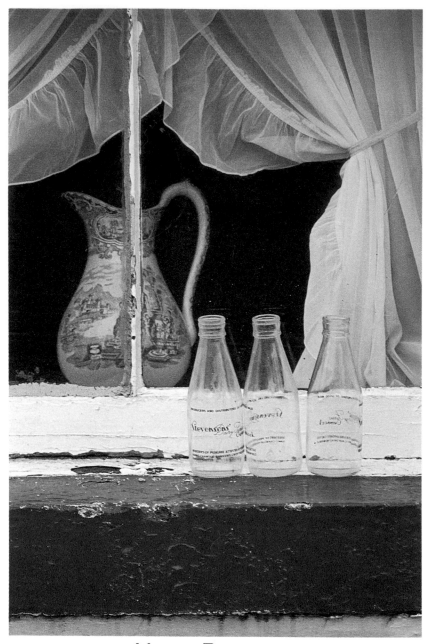

MILK · BOTTLES

44

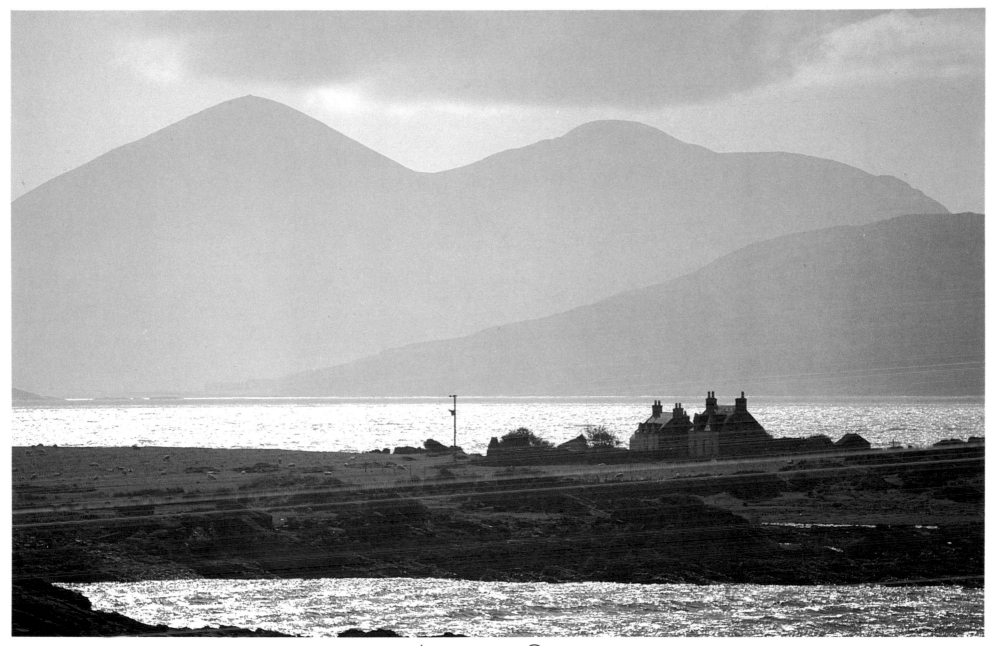

ISLE · OF · SKYE

45

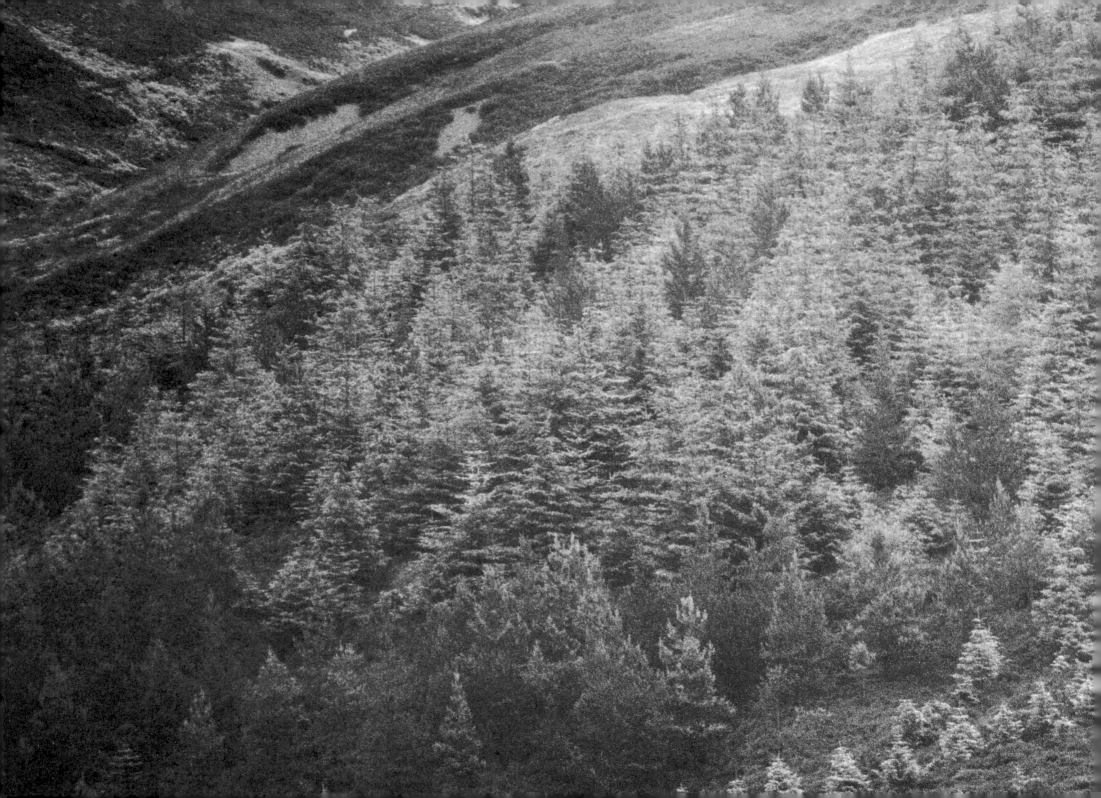

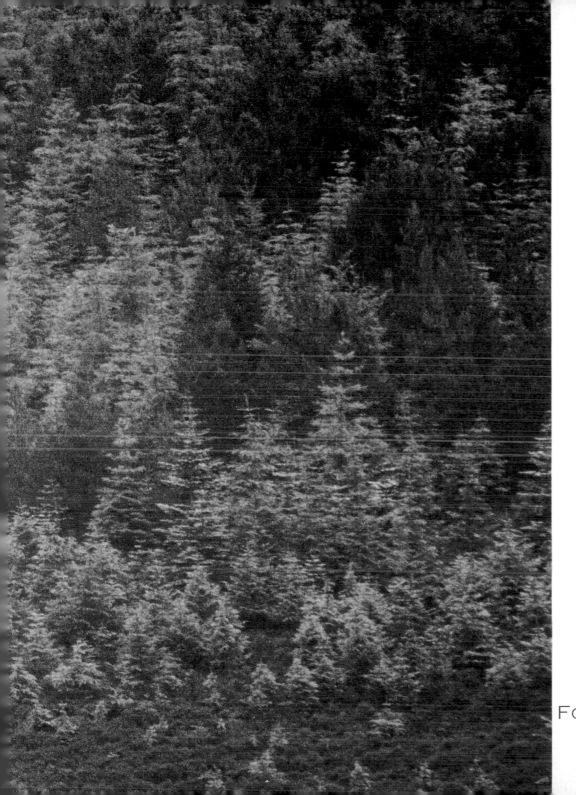

FORESTRY

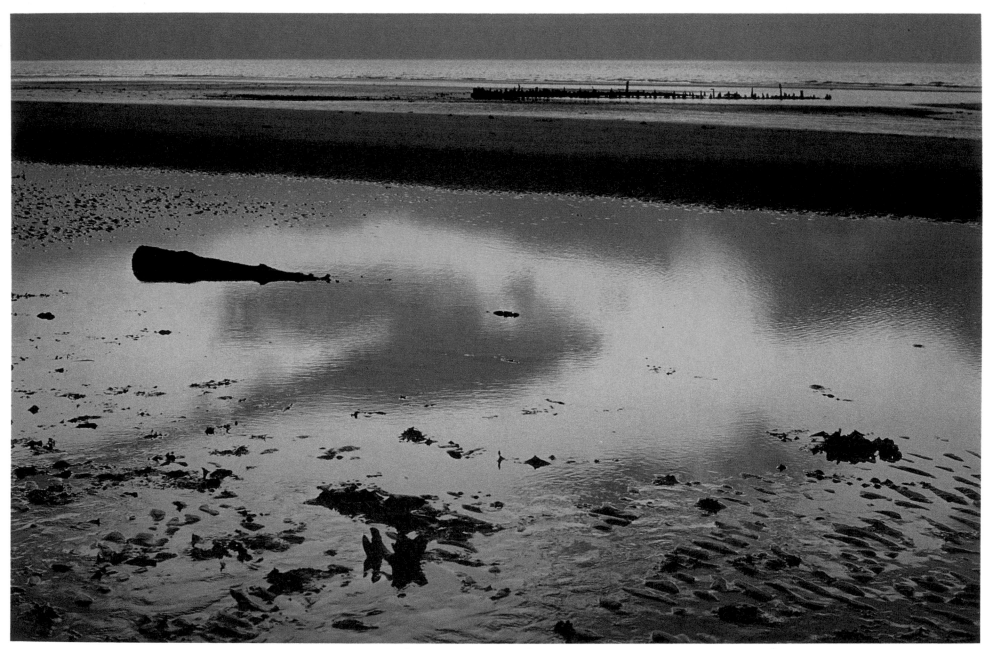

ABERLADY · SANDS

48

cropstrokes
scraping
brittle
colour
in the snow

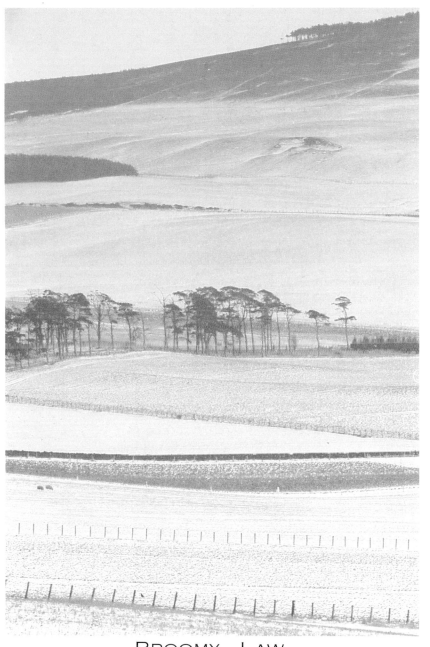

BROOMY · LAW

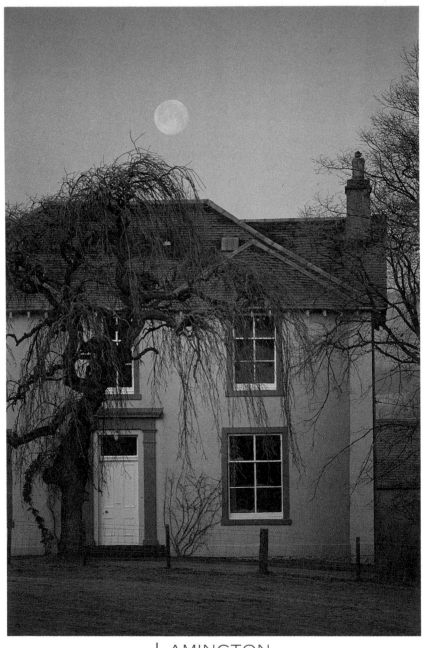

LAMINGTON

LESMAHAGOW

50

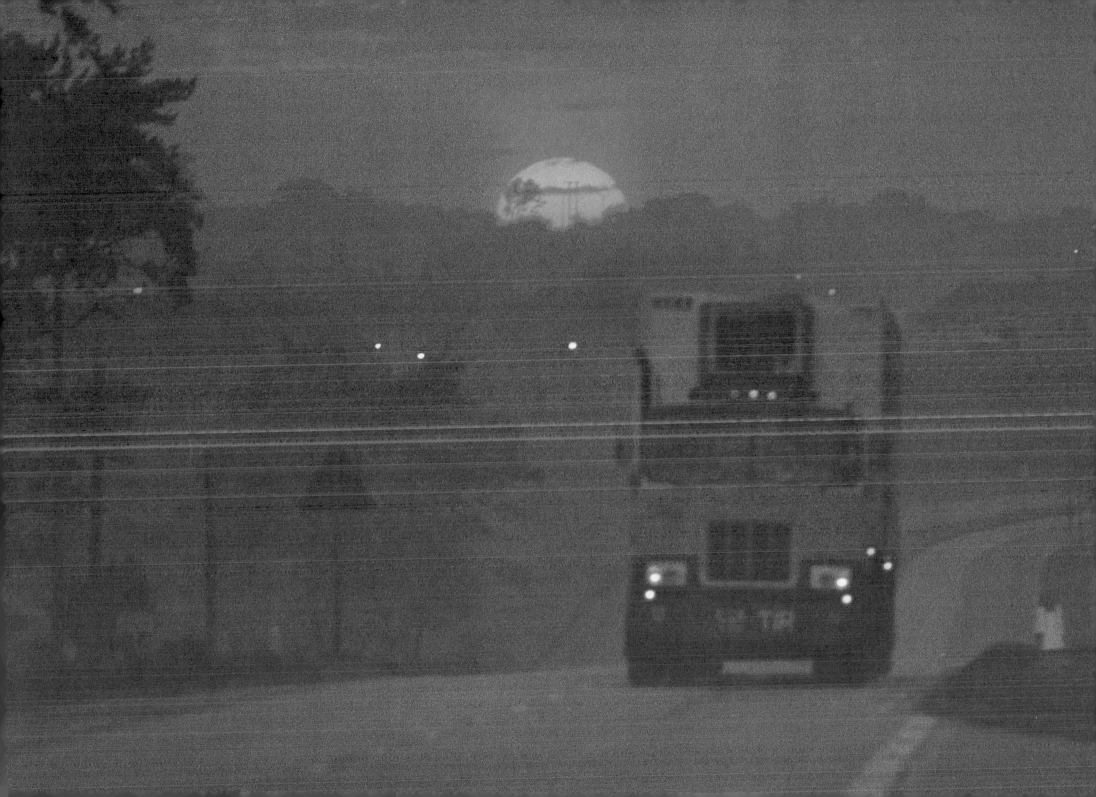

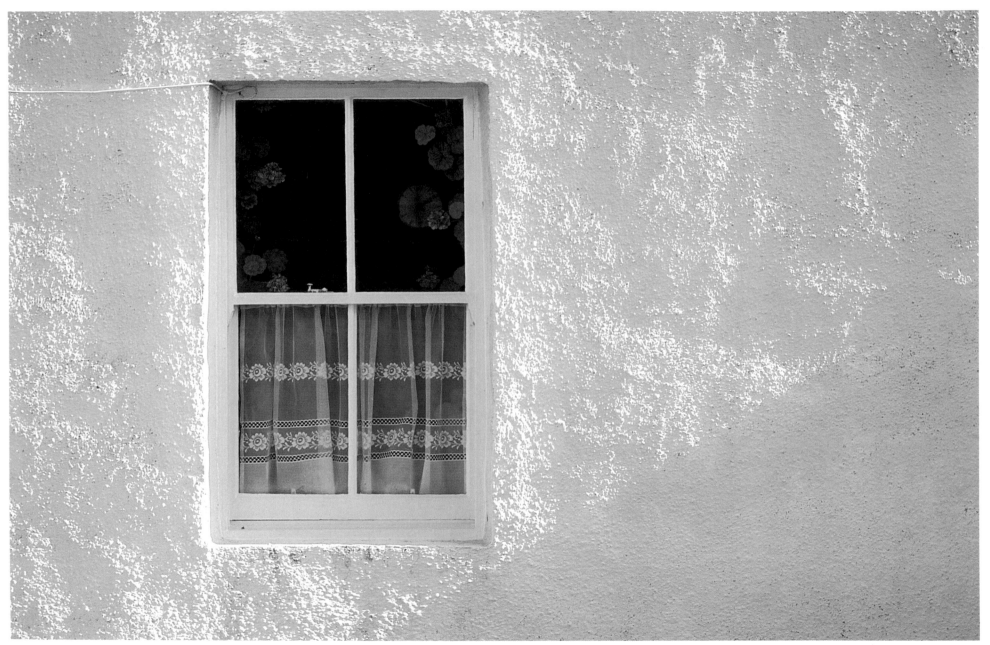

SHIELDAIG

52

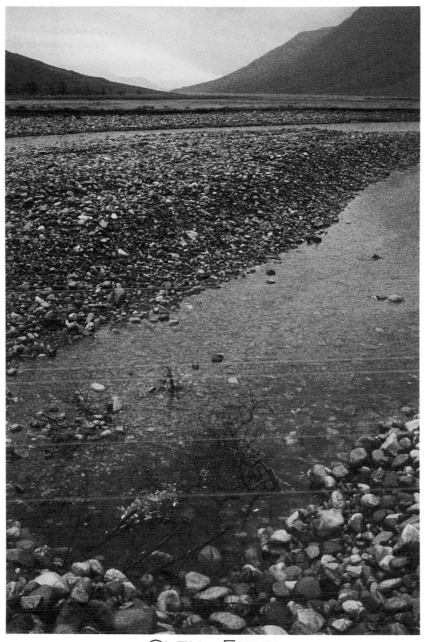

GLEN · ETIVE

53

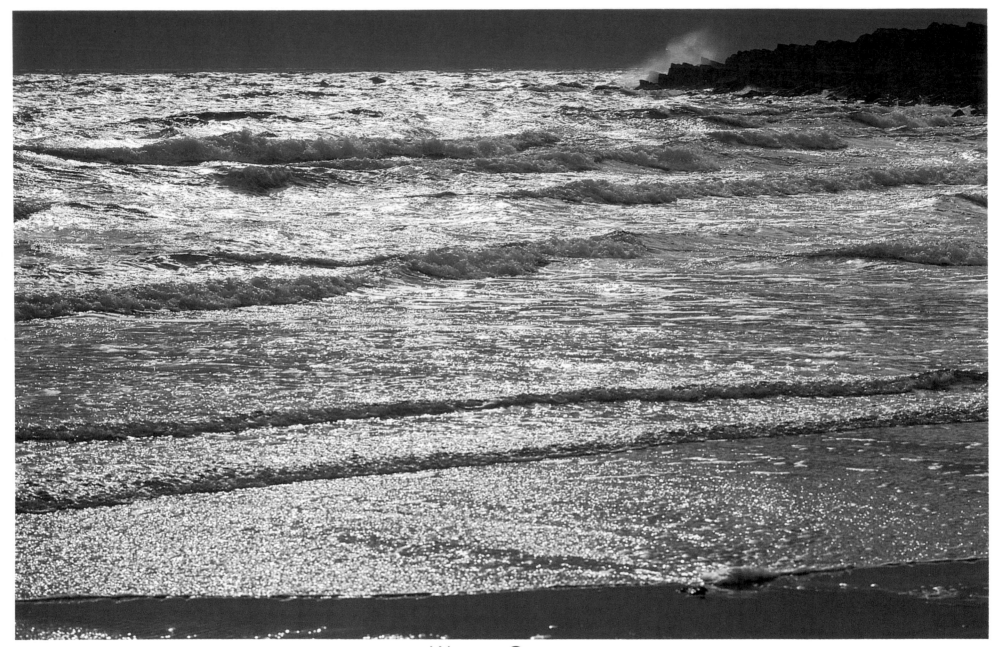

WEST · COAST

54

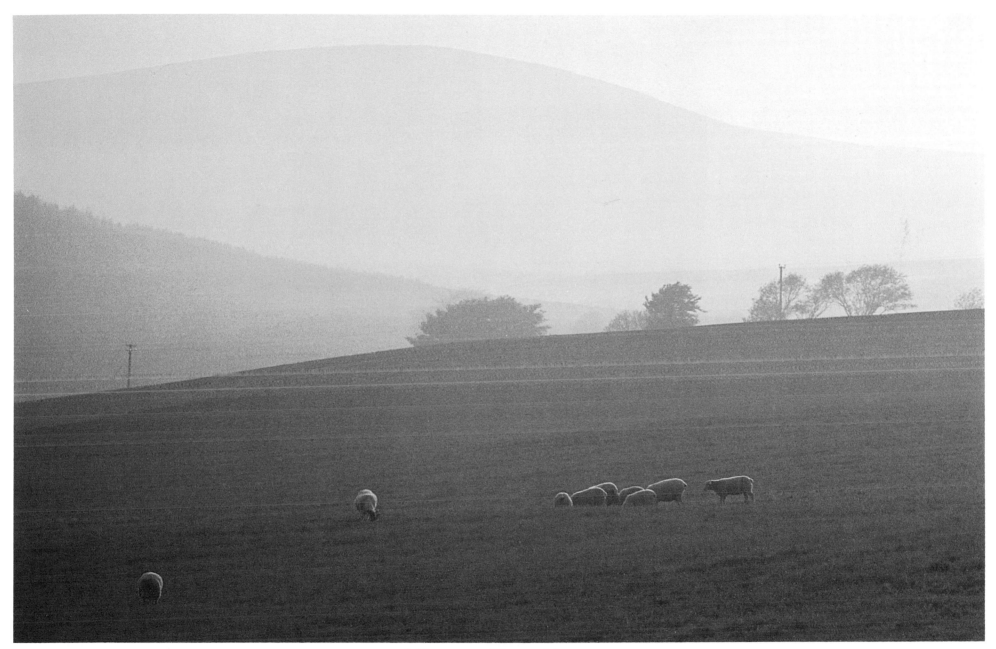

WHITE · RIG · HILL

55

iron
oxide
yellow
ochre
burnt
umber
raw
sienna
tempera
mutantur

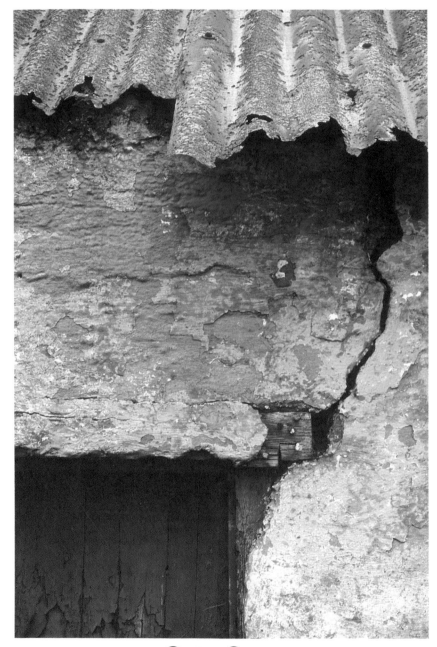

OLD · SHED

56

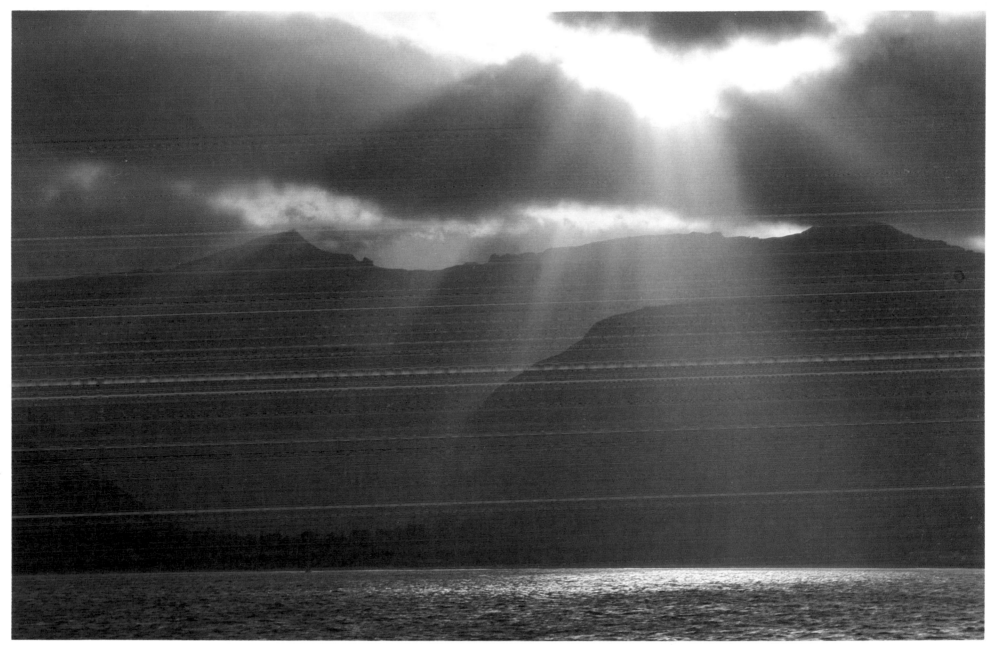

BRODICK · BAY

57

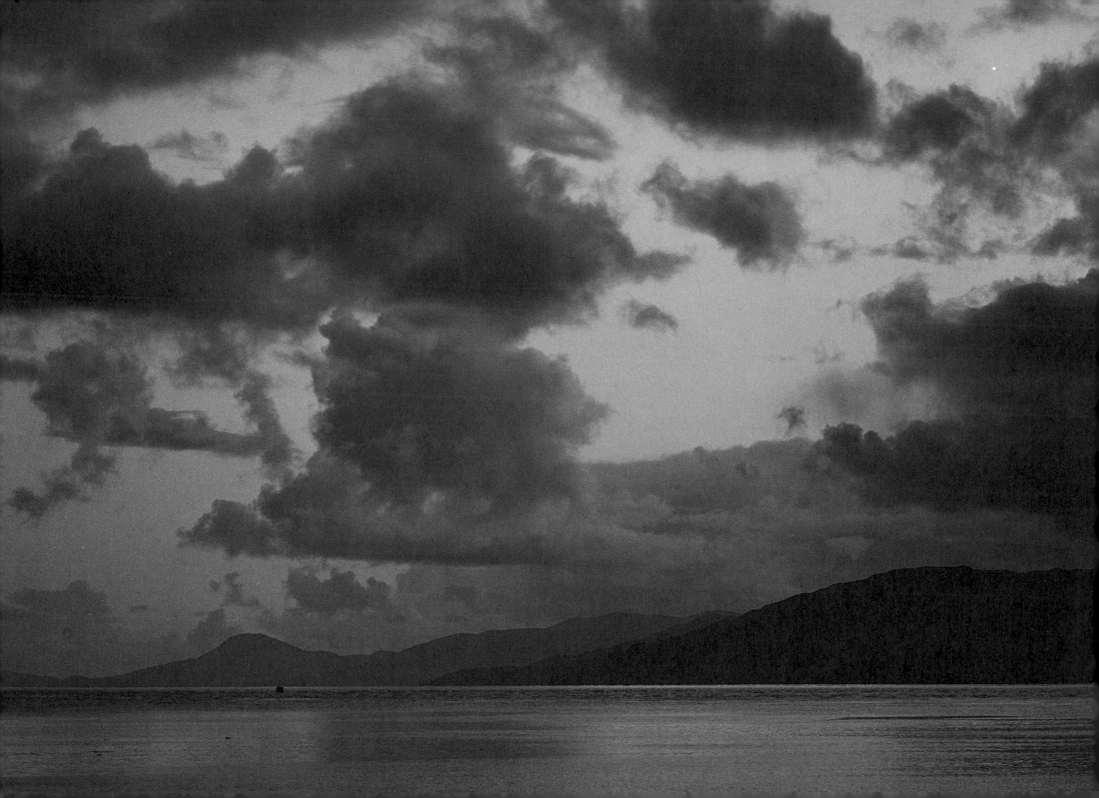

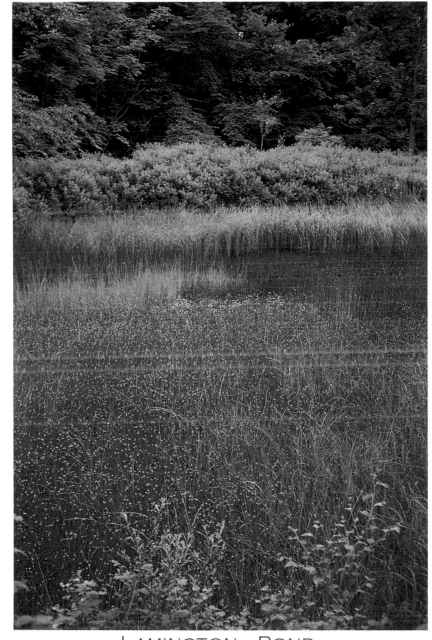

LOCH · LINNHE

LAMINGTON · POND

59

headlong
hung
the tumbled
precipice
of trees

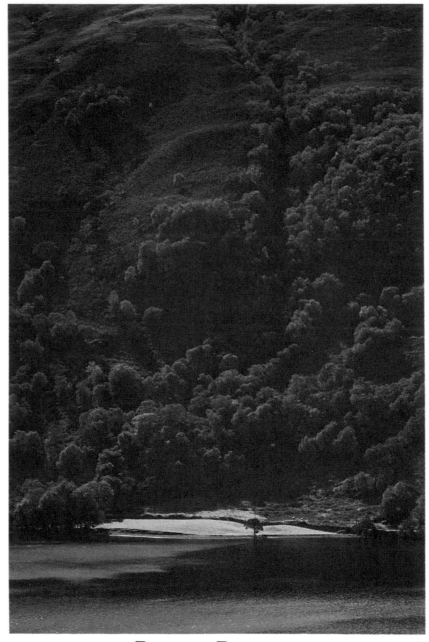

BEINN · BHREAC

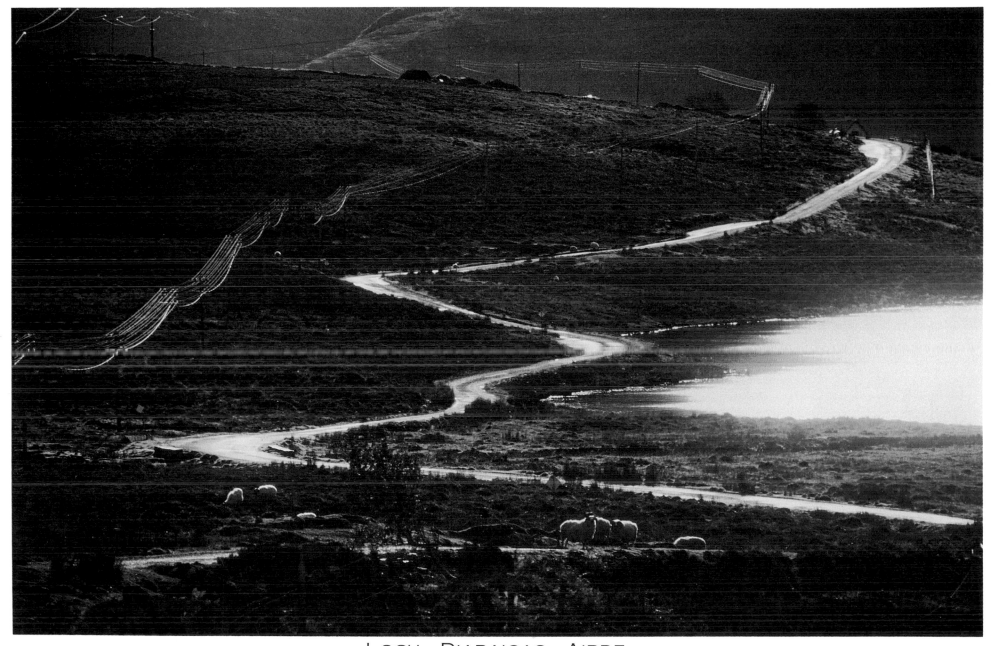

LOCH · DIABAIGAS · AIRDE

61

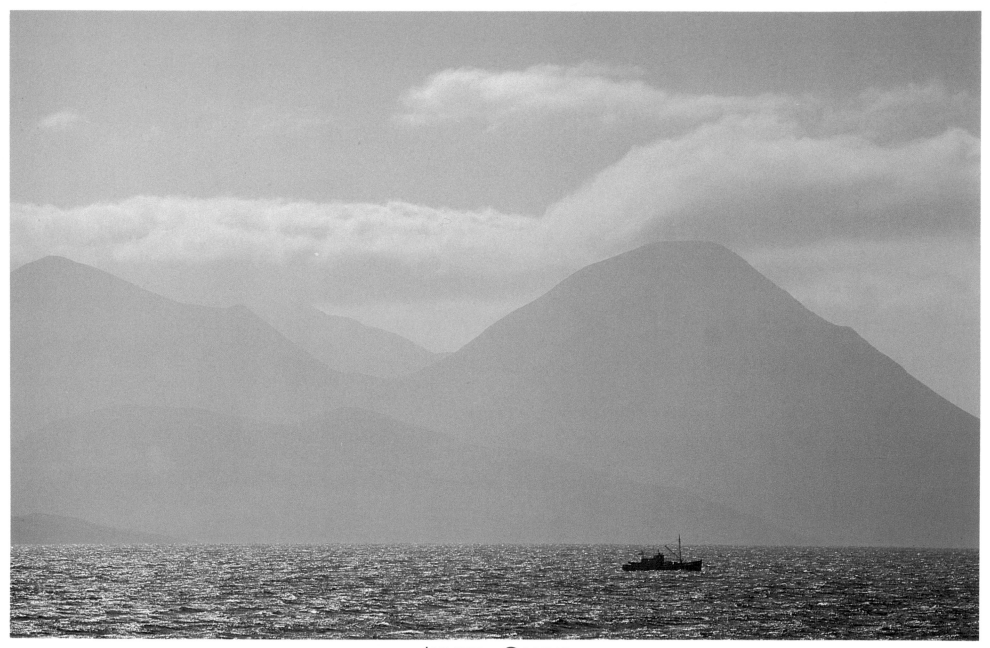

INNER · SOUND

62

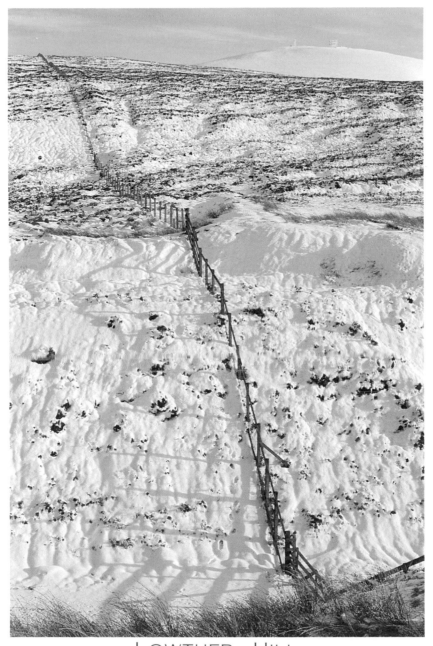

LOWTHER · HILL

63

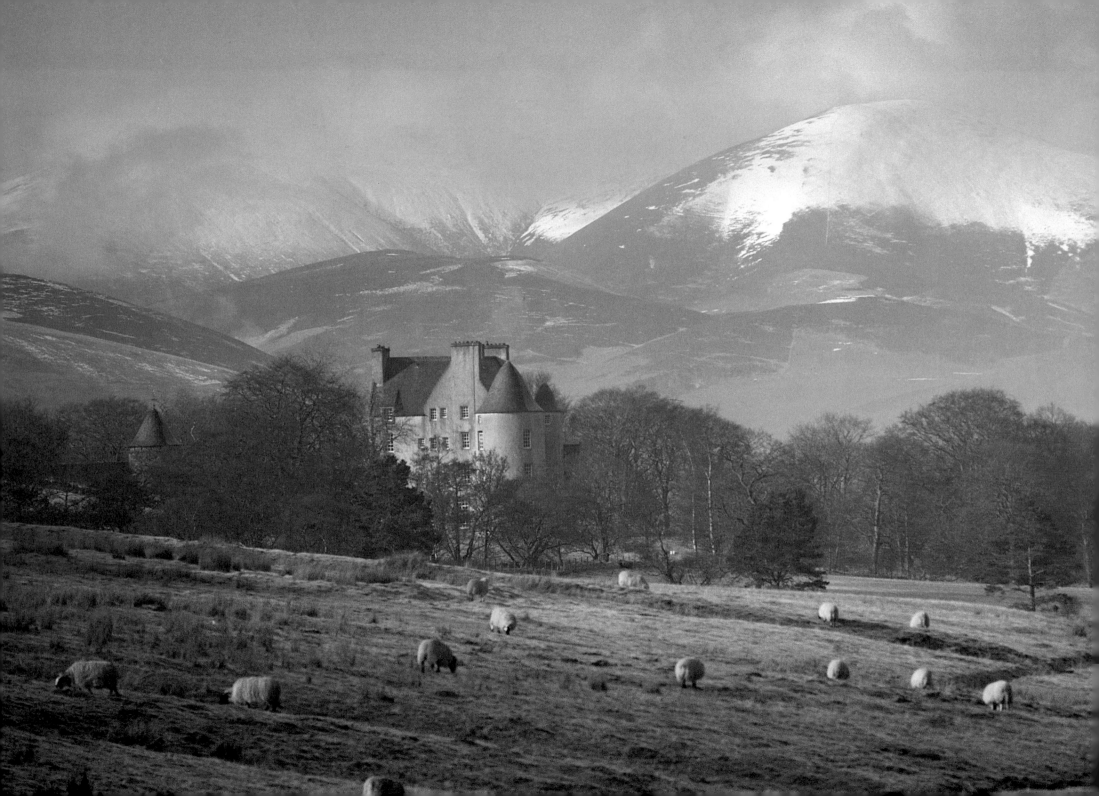

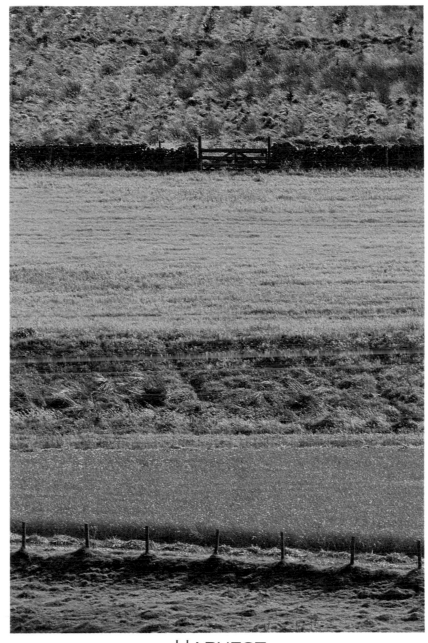

BROUGHTON · PLACE HARVEST

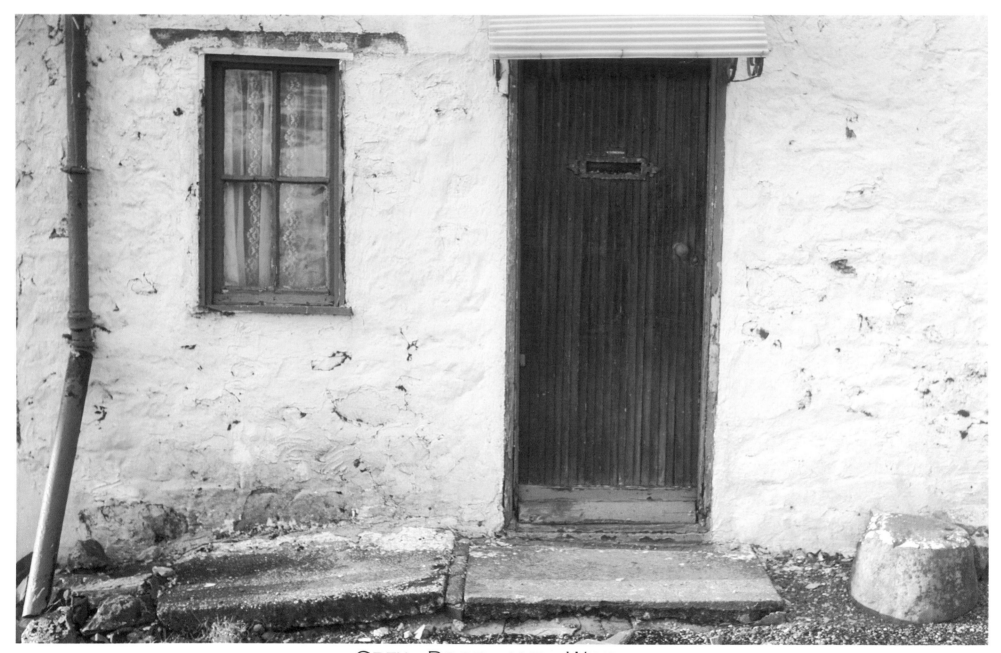

GREY · DOOR · AND · WINDOW

66

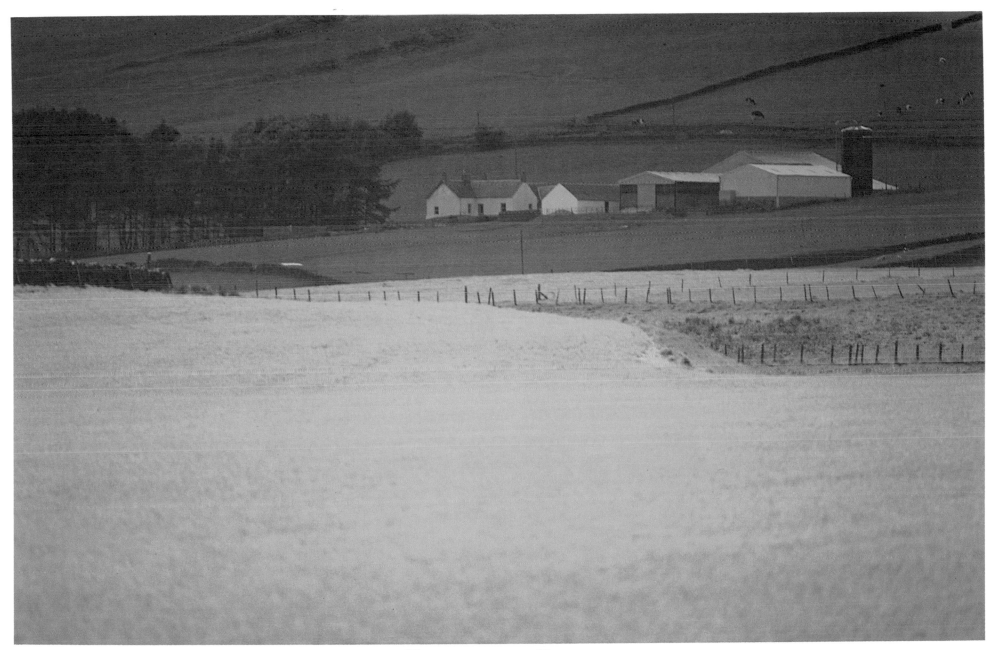

BOGHOUSE · FARM

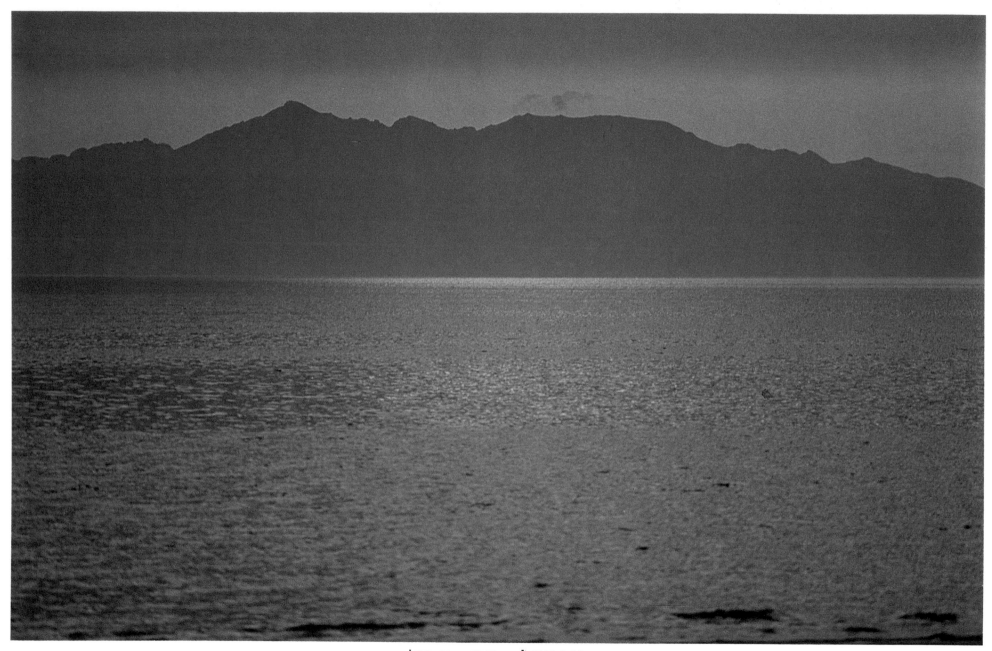

ISLE · OF · ARRAN

68

blue hills
sweep
dusk
across
untroubled waters

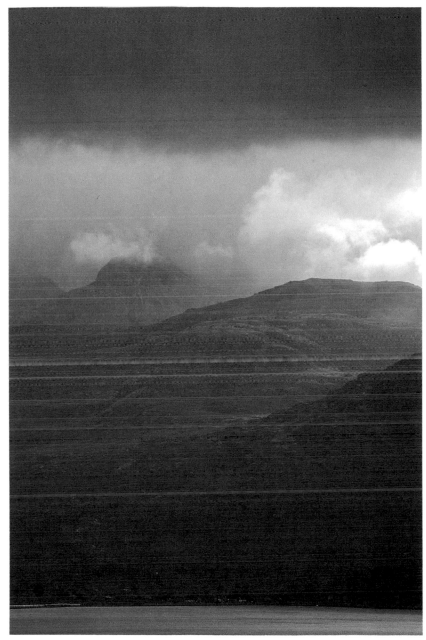

BEINN · DAMH

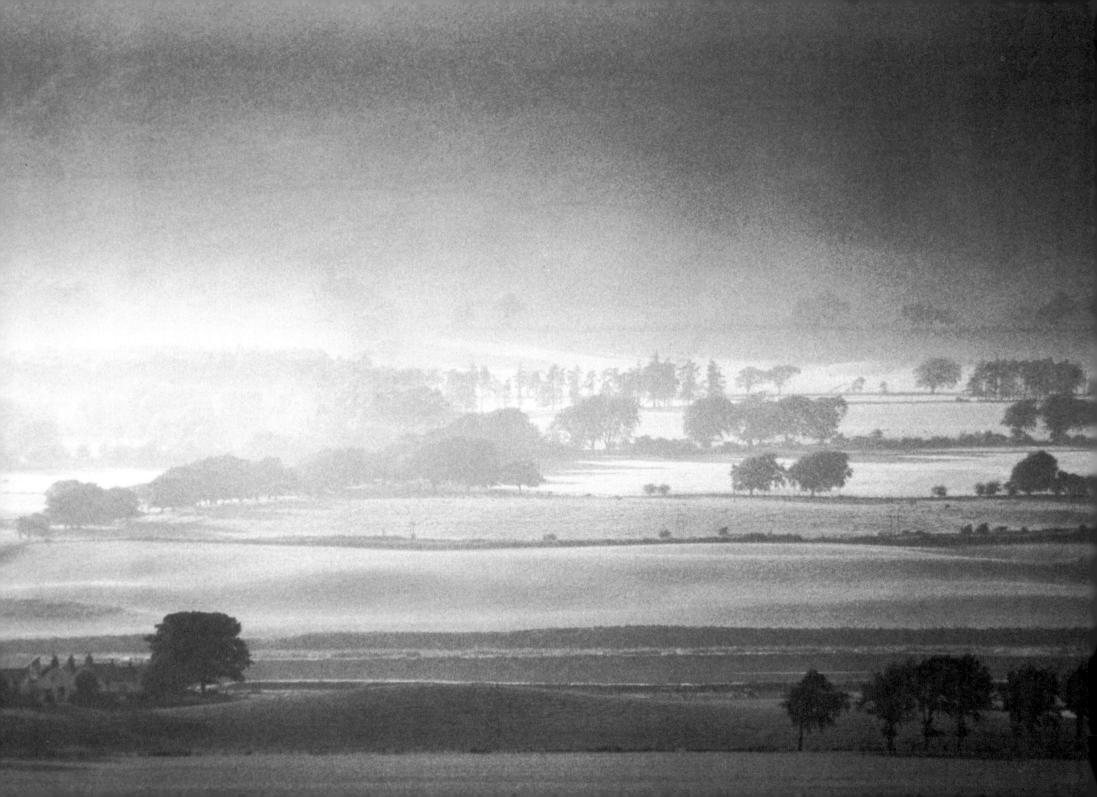

stone
cold
shouldering
the sting
of winter's
whip

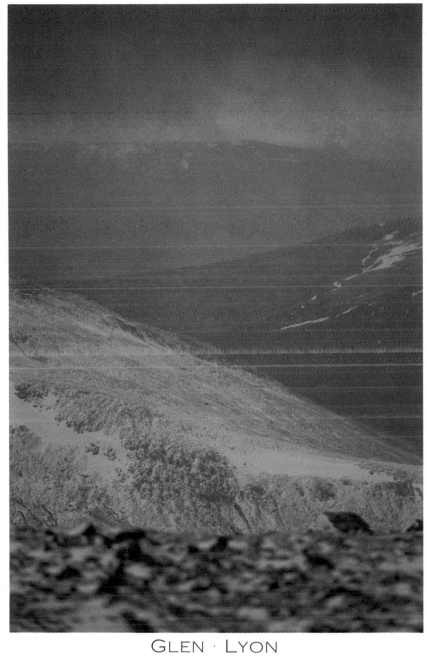

CLYDE · VALLEY

GLEN · LYON

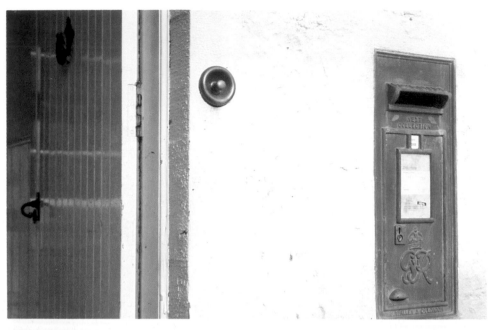

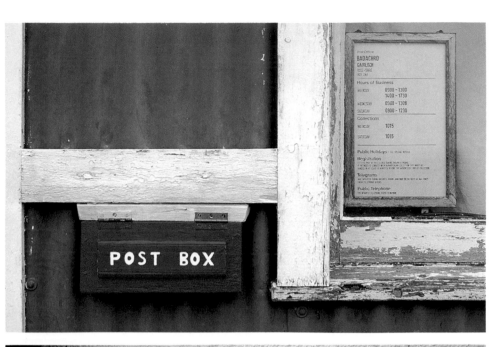

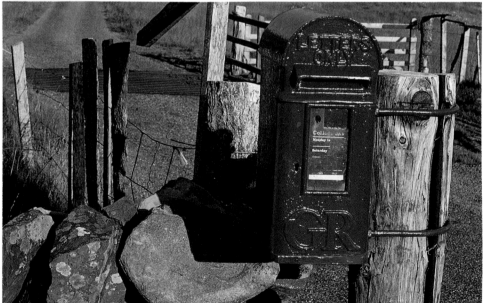

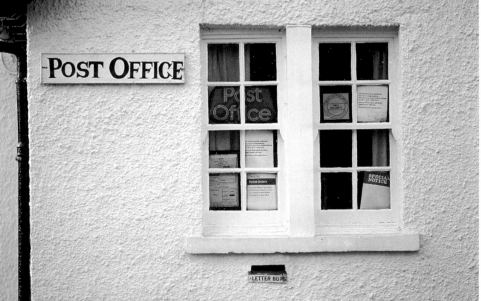

POST · BOXES

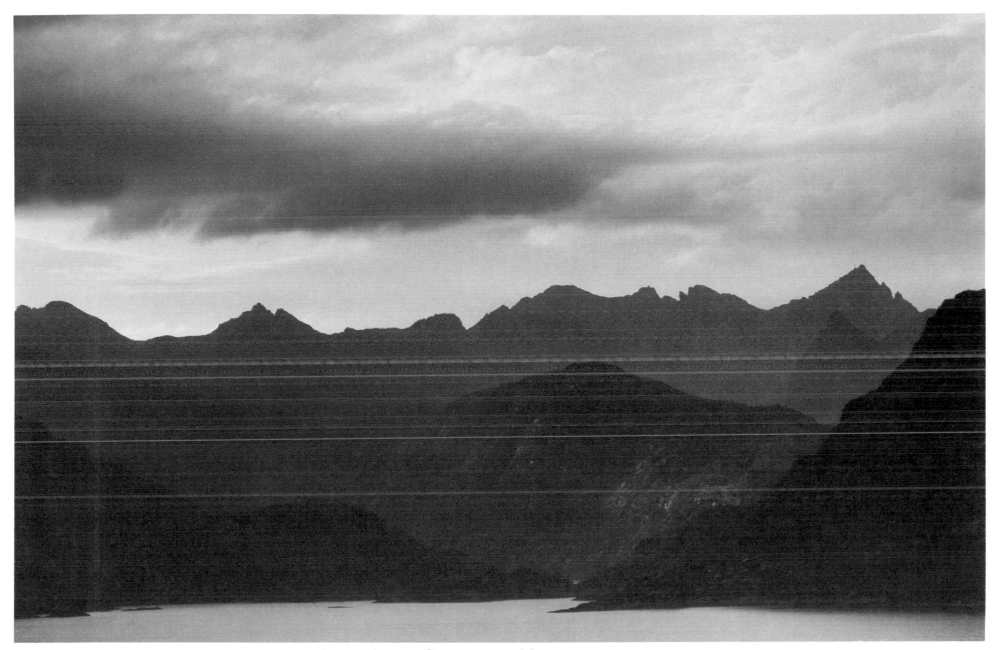

CUILLIN · HILLS

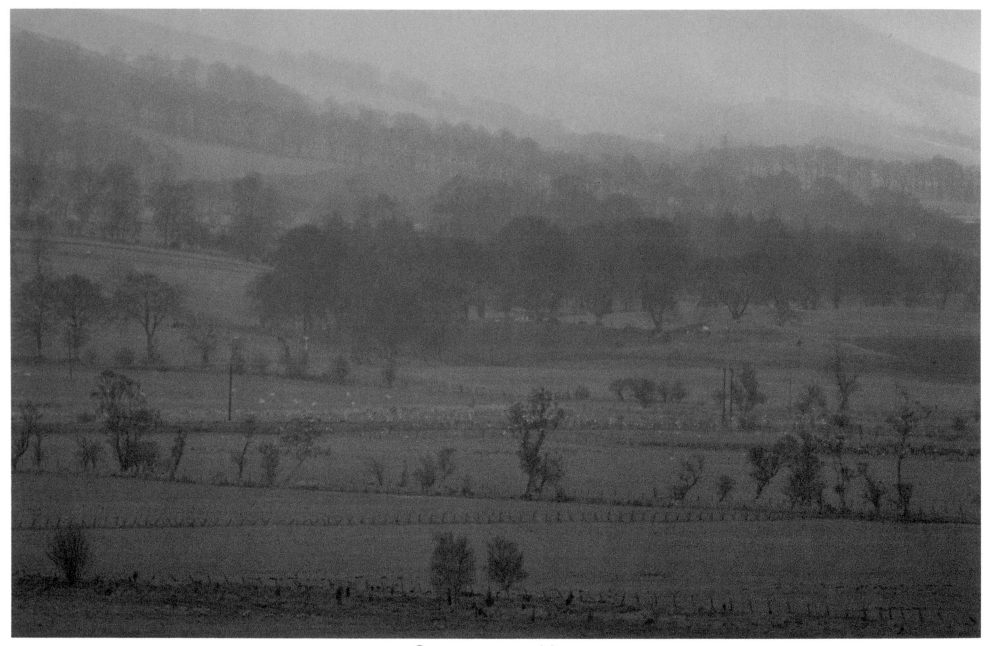

GOSELAND · HILL

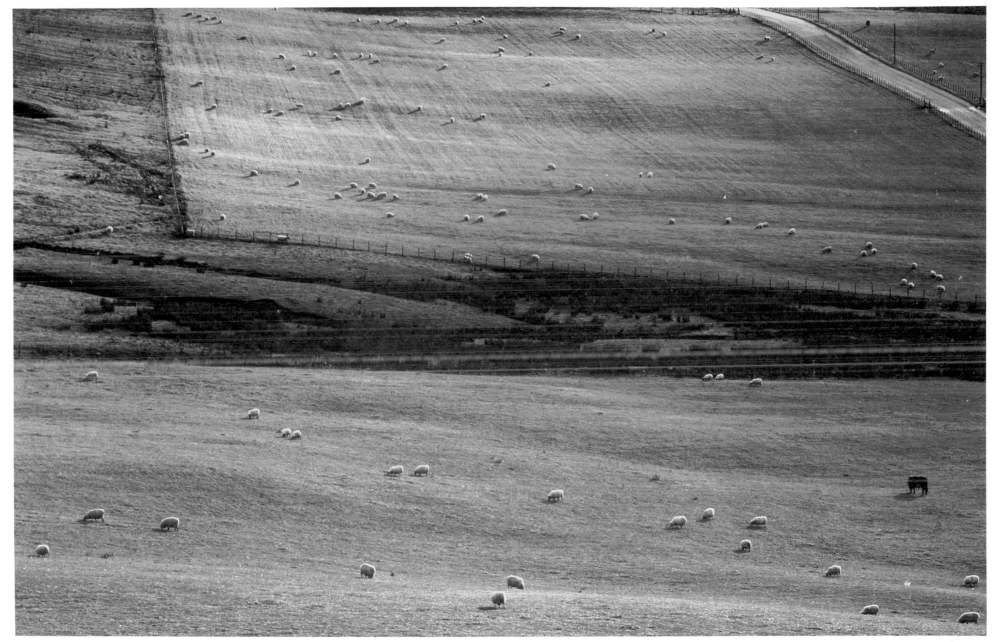

DUNEATON · VALLEY

75

sea
sand
grass
in shades
of wind

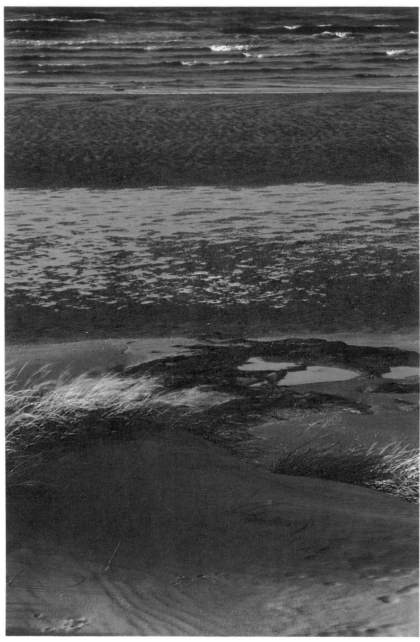

LOW · TIDE

76

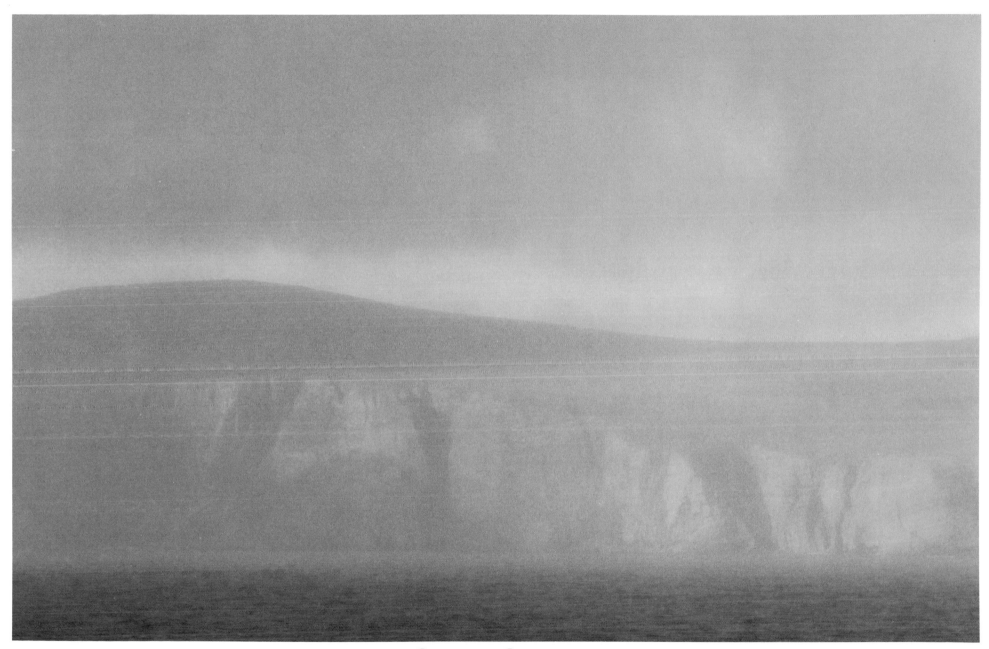

ORKNEY CLIFFS

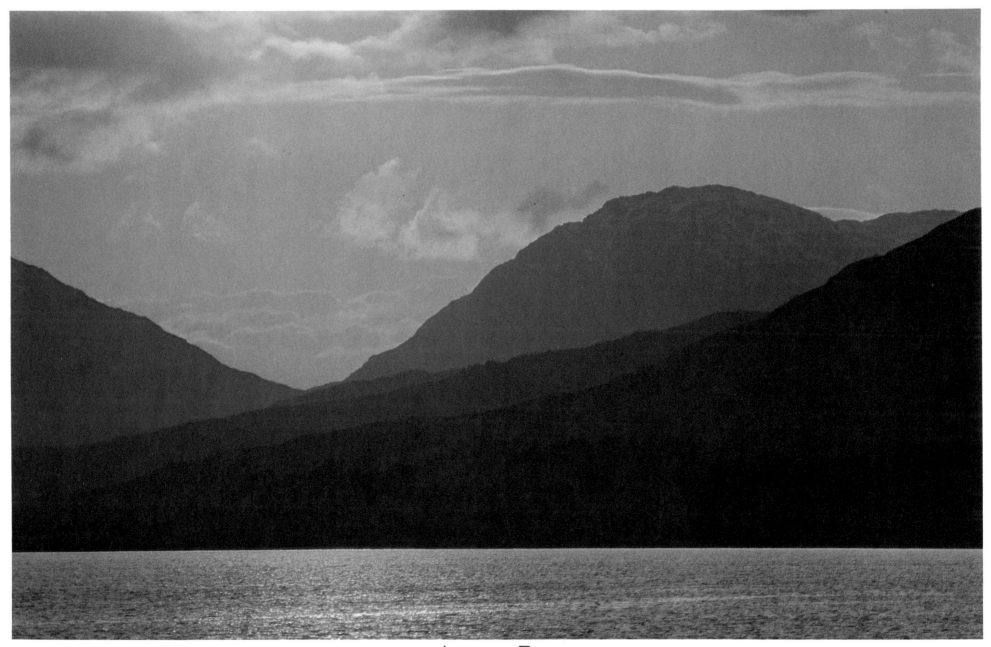

LOCH · EIL

78

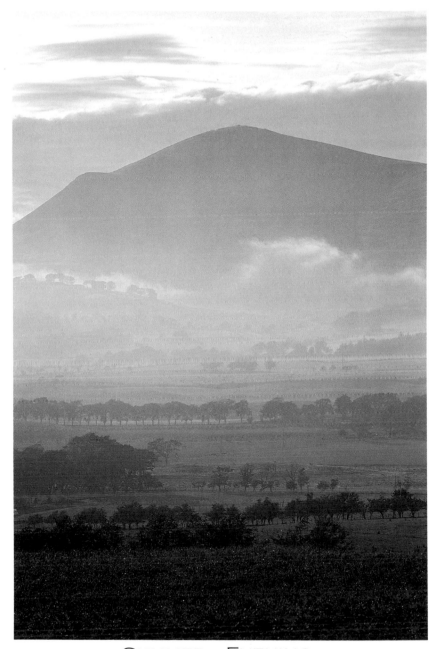

SUMMER · EVENING

79

slopes
fingering
the mist
with trees

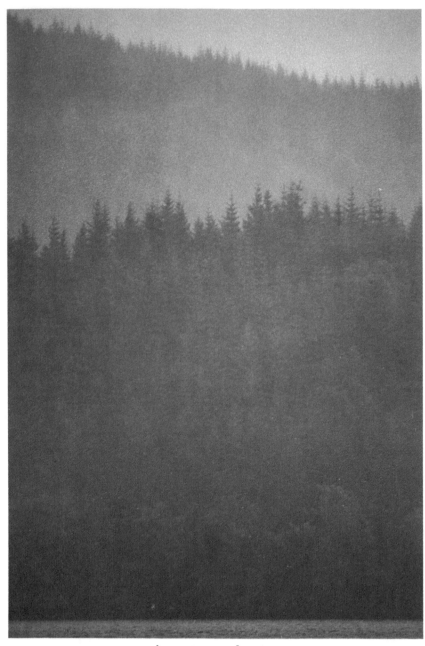

LOCH · ARD

WINTER · BORDERS

80

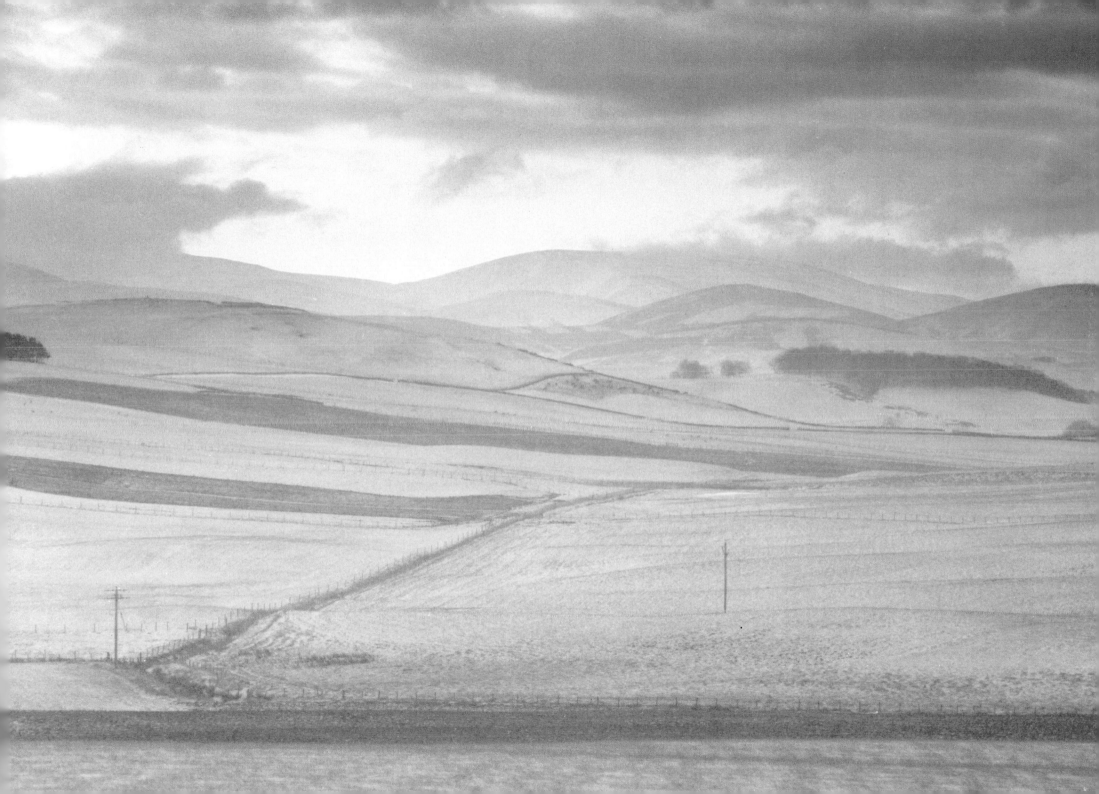

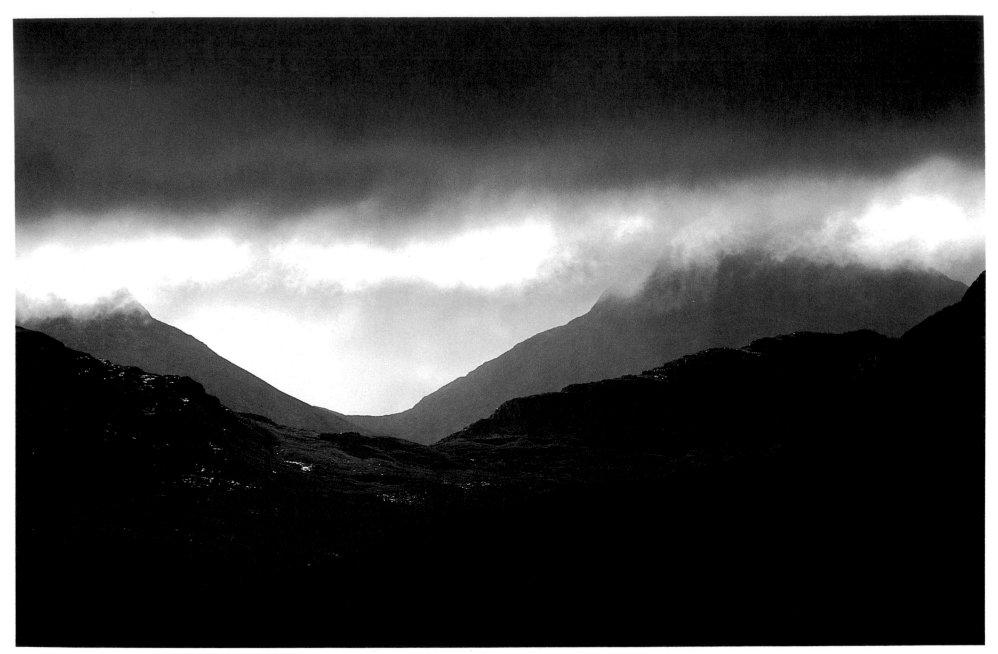

BEN · SHIELDAIG

82

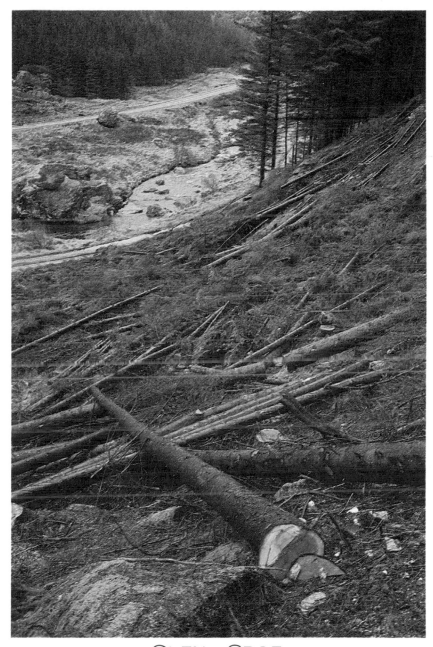

GLEN CROE

83

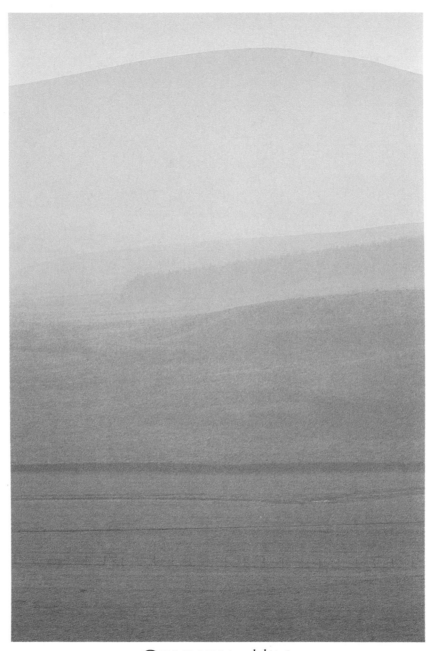

COMMON · HILL

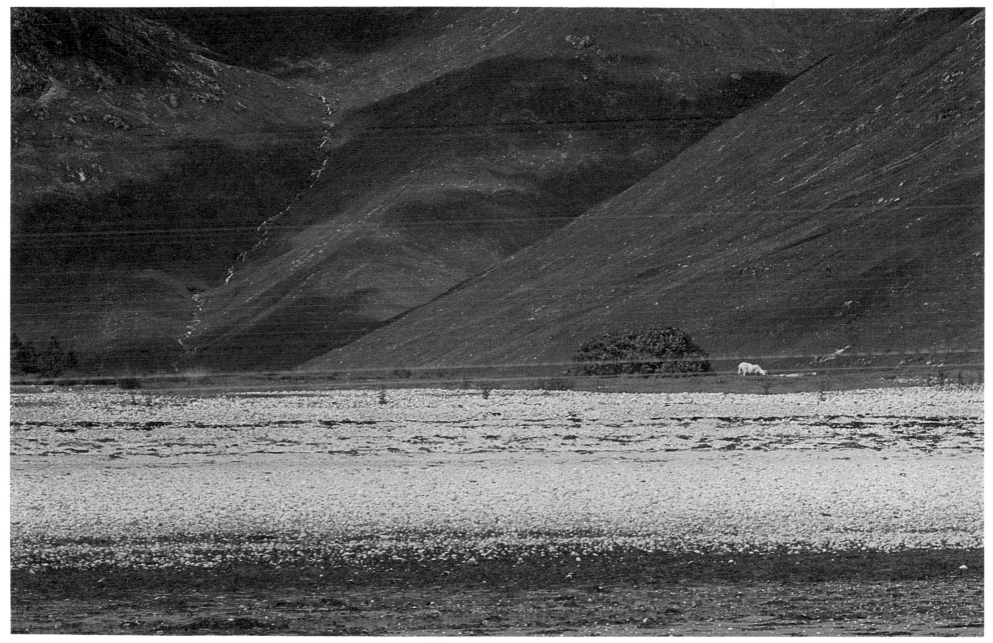

KINGAIRLOCH

85

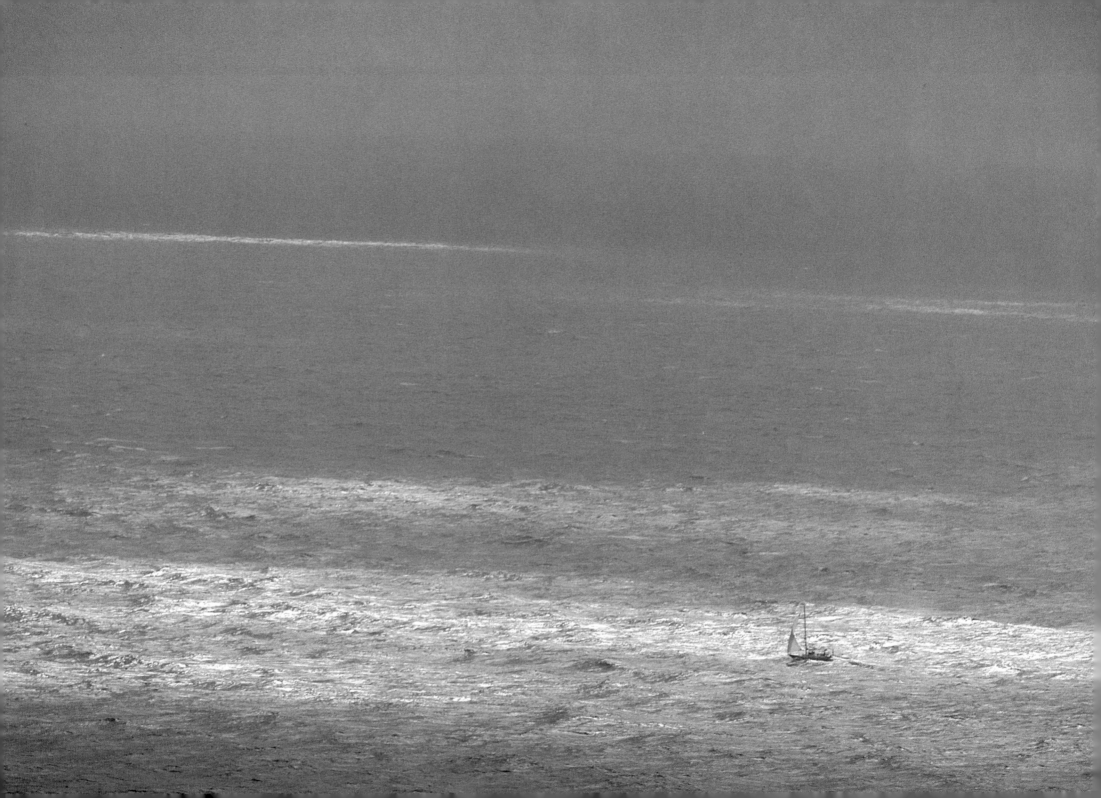

flake
white
lead
grey
wind
bite
keel
spray

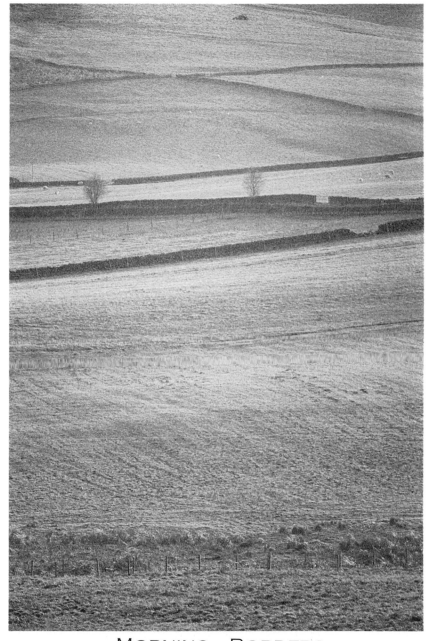

SILVER · SEA

MORNING · BORDERS

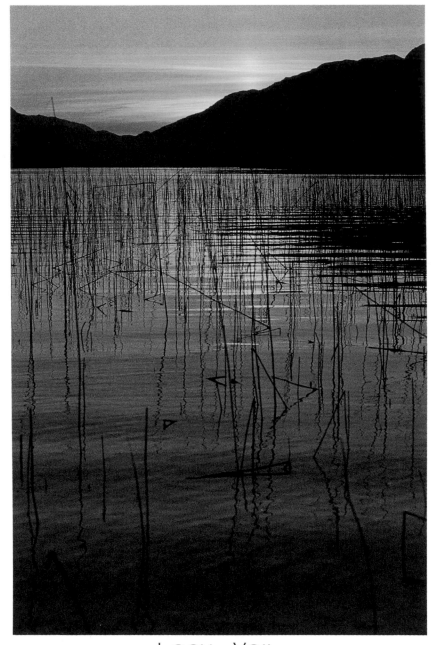

LOCH · VOIL

88

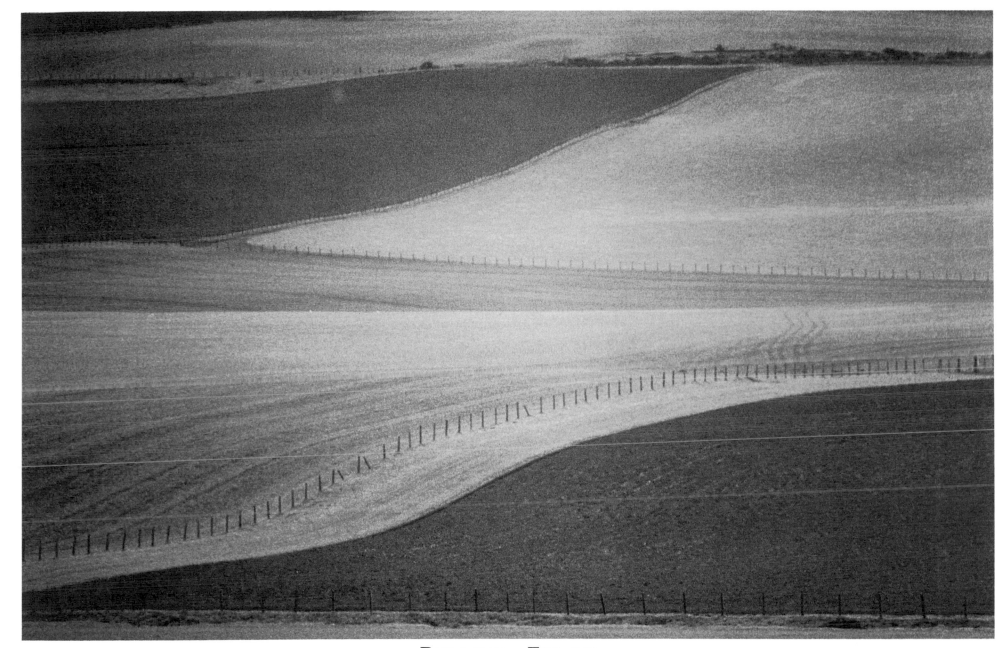

ROLLING · FIELDS

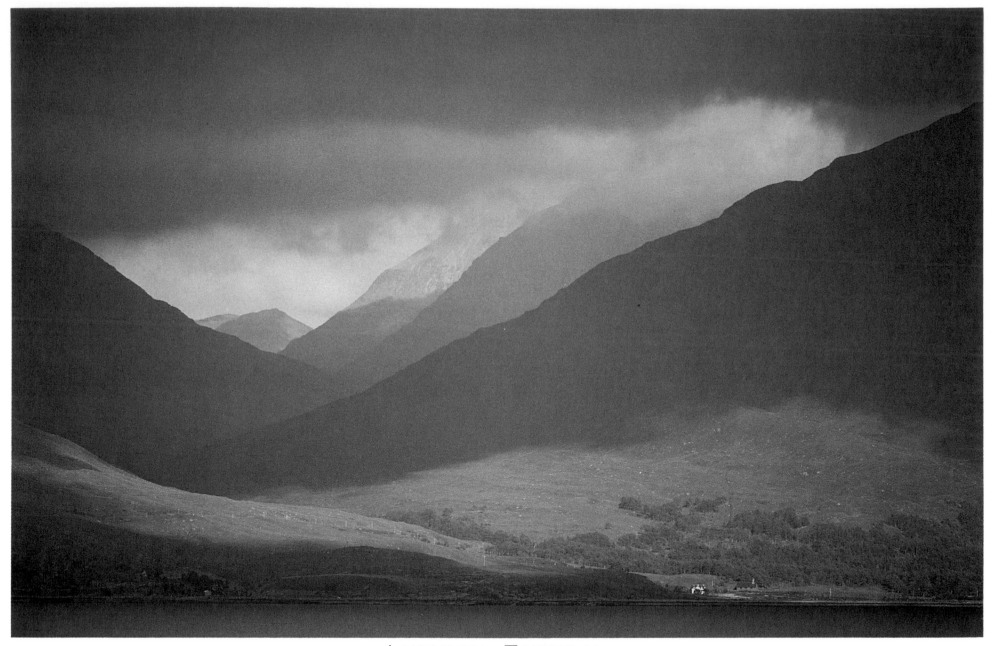

LIATHACH · TORRIDON

90

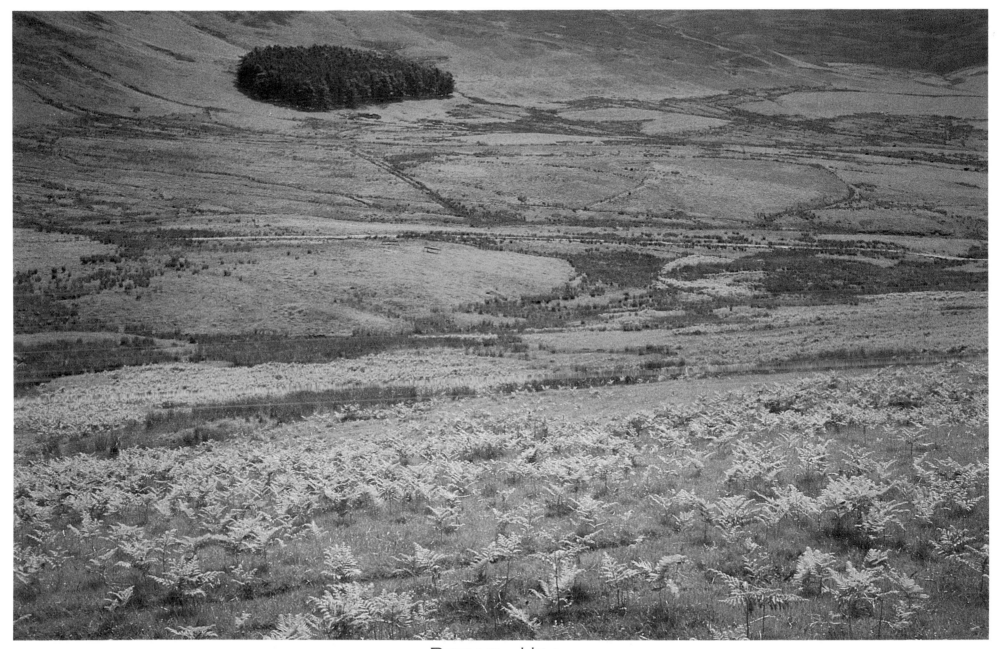

BROAD · HILL

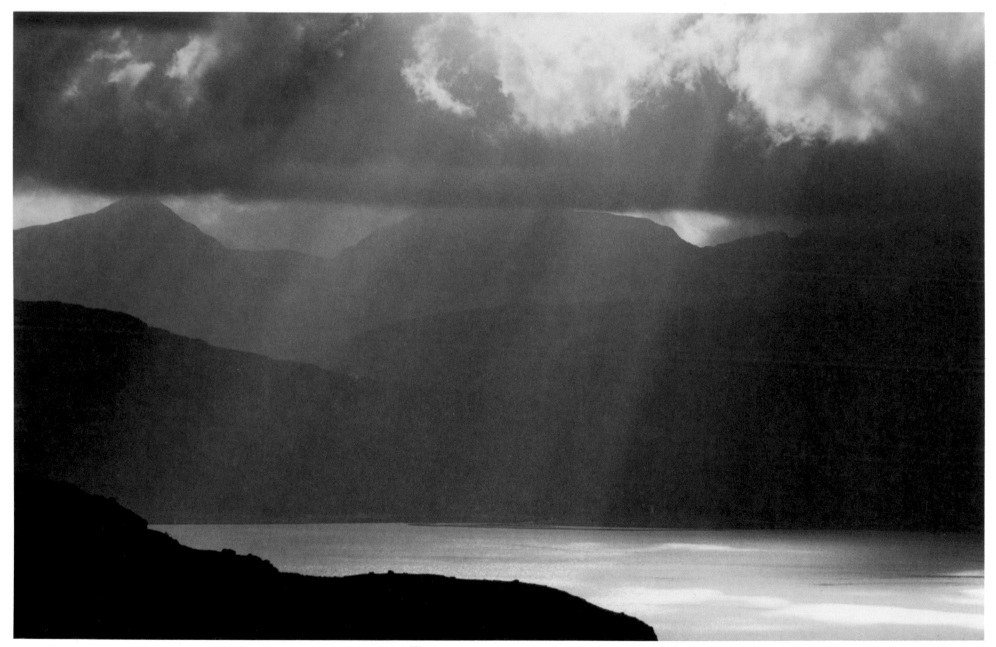

TORRIDON · HILLS

92

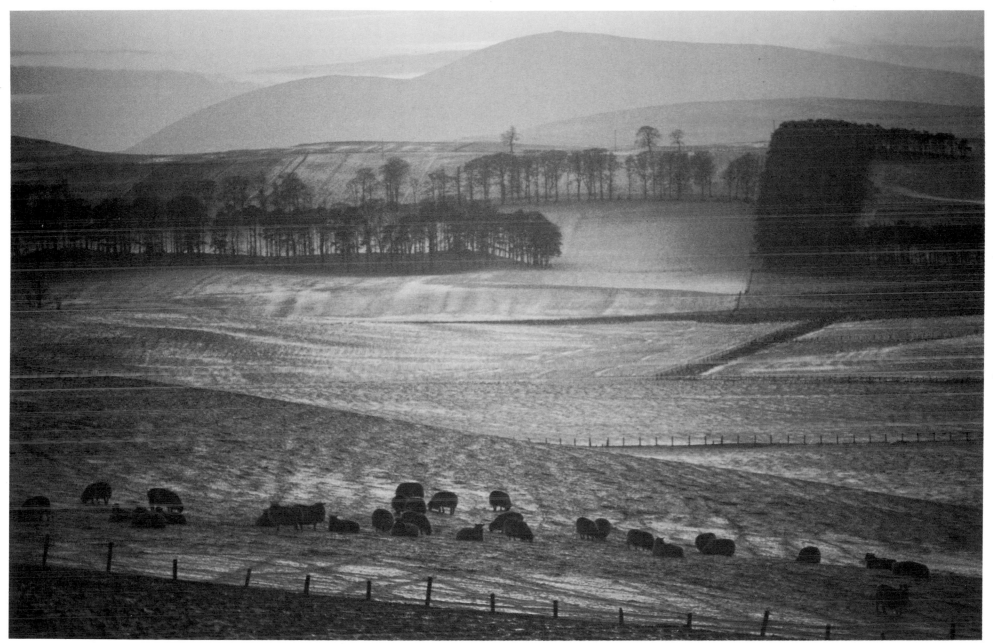

TINTO · HILL

93